T78.8

SPECIAL EFFECTS IN PHOTOGRAPHY

Robert Haas

J.M. Dent & Sons Ltd
London Melbourne

First published 1985
Text © Robert Haas 1985

This book is set in 10/13 Linotron Trump Mediaeval by
The Word Factory, Rossendale
Printed in Singapore by
Imago Publishing for
J.M. Dent & Sons Ltd
33 Welbeck Street, London W1M 8LX

British Library Calaloguing in Publication Data

Haas, Robert
 Special effects in photography.
 1. Photography—Special effects
 I. Title
 778.8 TR148

 ISBN 0–460–04694–2

Contents

ACKNOWLEDGEMENTS

The author would like to thank the following persons for their help in this publication: David Burnham, Julian Seddon, Roland Schenk, Annabel Hodin, Marie Helvin, John Swannell, Phil Jude, David Hockney, Karen Kuhlman, Cavan Butler, David Graves, Professor R.A. Weale (Institute of Ophthalmology, University of London), Professor David W. Hill FRCS, Bill Kingdon, Danny Halperin, Sue Davies, Dorothy Bohm, Robert Ginnett, Desmond Green, Michael Wenyon, Susan Gamble, Brian Davies, Jennifer Manton, Sue Mann, Jim Baker, Anne Marie Erlich, Mark Trew, Dennis Orchard, Terry O'Neill, Valerie Lawton, Bruce Brown, Georgiana Hutchinson, Zelda Cheatle, Martin Harrison, Tony McGrath, George Newkey-Burden, Michael Rand, Geoffrey Crawley, Paul Brierley, Cornelia Fielden, David Warr, Arthur Steel, Ann Davies, Gary Kewley, Robert Golden, Patricia McCabe, Samantha Miller, Edwina Olins, Michael Duffy, Brian Griffin, Karena Perronet-Miller, Bryce Attwell, Chris Wordsworth.

Also: Brian Daniel of Syndication International Ltd, Andrew Parkhouse of Polaroid UK Ltd, Susan Foister and Terence Pepper of the National Portrait Gallery, Simon Kitchen of the British Museum Medieval Department, Helen Thorburn of the Daily Telegraph, and John Davies, Bernadette O'Leary, Tim Lund and Karen Brookes of The Daily Telegraph Colour Library. Mark Sutton of The London Chamber of Commerce and Industry.

Irving Penn's 'Vitrier' is reproduced by courtesy of Vogue, copyright © 1951 Les Editions Condé Nast.

Irving Penn's 'Glowing Embers Poppy' is reproduced by courtesy of Vogue, copyright © 1980 Irving Penn.

INTRODUCTION

Putting images and the things that we perceive through our eyes on to paper and film, via the simple and yet sophisticated tool of the camera, is as difficult at times as putting pen to paper. The unique form of communication that the camera offers us through its refined language of focused light rays enables us to speak a universal tongue, one that relates immediately in the image that it produces to our everyday experience of seeing the world. We may know instinctively that when something is the result of experience, it has the ring of truth about it. The camera in its limited way makes a very good job of imitating reality. While it will never succeed totally, since it is not human, we may assist its rather simple view of the world and so help it to convey a better notion and a more truthful impression of the nature of things.

We cannot totally trust the camera, it *is* capable of lying, but we may to some extent trust our own judgement, and therefore through the careful management of camera and film, and through the camera's medium, we can attempt to convey our best visual sense.

A visual special effect is not something that we should have to look hard for, but rather something that occurs to us as naturally as any other nice surprise. If anything, we need to sharpen our awareness in order to be prepared for the more eccentric event, and for us then to be swept off our feet by that weird and wonderful spectacle. Since there is ultimately no conventionalized form for a great photograph, we can only trust our eyes and our inner response to what we see as spellbinding. If we feel we are captured by something that we come across, then it is important for us to stop and consider the fact that we have indeed been moved by that article or that combination of features. The photographer should of his very nature regard nothing as incidental. Things that are of the moment are for the camera of the essence. If you weren't quick enough to get it, then there's absolutely no excuse. You should have been ready for the possibility.

A special effect in a photograph is something that can come about through the sheer impact of the subject itself on our senses, and this is where our own response is all that is required for the making of a brilliant picture – nothing more. On the other hand, a special effect in a photograph can also be brought about through our own more considered method and approach to that readily available subject. We may therefore impose some quality on the image that we produce. There are, strictly speaking, no guidelines for this exercise, other than to say that an imposed technique should probably be sympathetic in its character to the nature of the subject.

A really special effect in a photograph should show itself not just as a clever technique, but rather as something operating in conjunction with the photograph's subject that strengthens the total image in such a way that if you were to take that element away, then the picture would be effectively weaker. One element should to all intents and purposes rely on the other. Since simplicity is so important in a great photograph, it is very difficult in most cases to use a specialized method or technique in a photograph without actually obscuring or utterly destroying the feel of the subject. Applied judiciousness is as important as applied science. Progress may be slow as long as it is sure in this respect, and a jump in at the deep end, in photographic terms, could be your last one.

Of course one can get ideas for taking photographs from here, there and everywhere, whether in the field of painting or mechanical engineering. However, the greatest thing to avoid is to allow oneself to be over-influenced by any

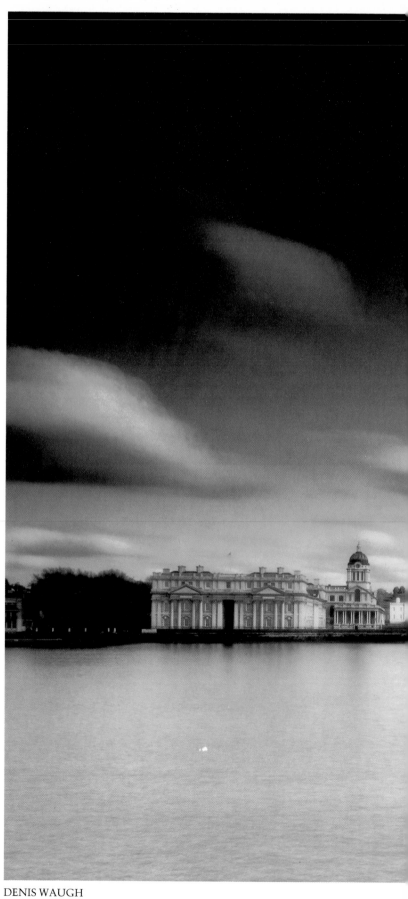

DENIS WAUGH

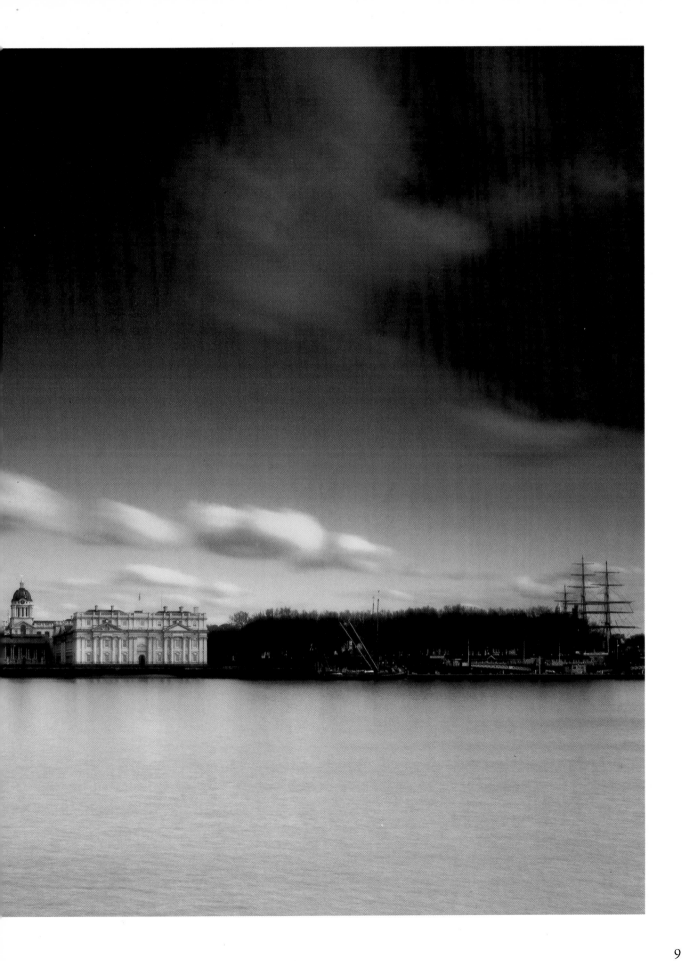

ROBERT HAAS

DENIS WAUGH

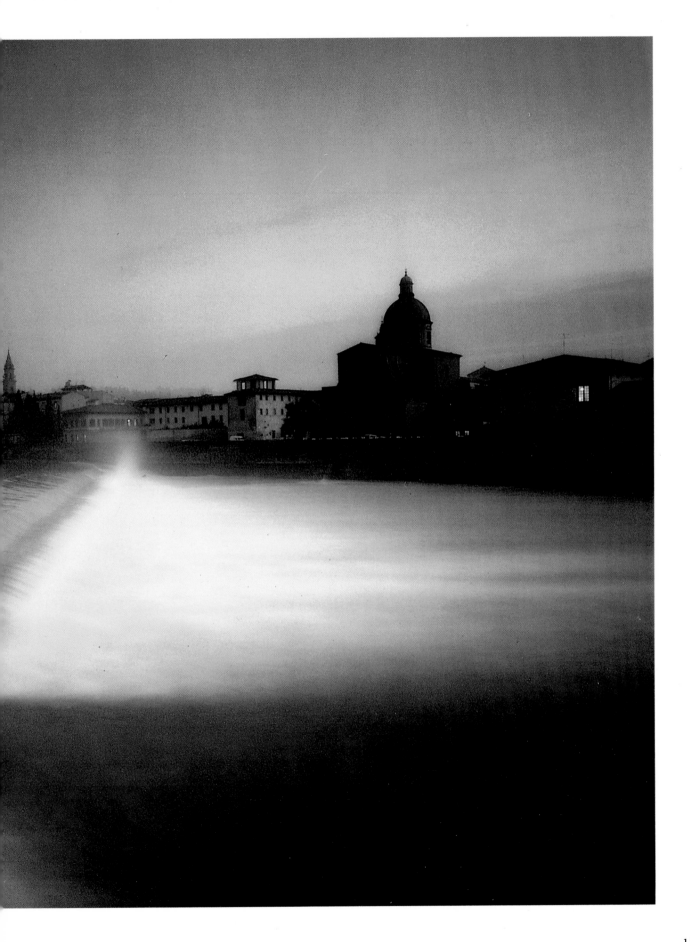

HOOVER BASE-PLATE BY ROBERT HAAS

one discipline and in isolation. Although a great photograph often does have a distinct quality that can be tied down to a specific field source, nevertheless it is that extra and almost untraceable 'something' which really makes the picture. From this standpoint it is very important for the photographer to absorb naturally and easily as much extra-photographic source material as is humanly possible. The presence of such source substance to the mind's eye will inevitably emerge in the photographer's final work, and often without the photographer knowing it.

Every subject of our eye – and without exception – has a quality to it. We could say that everything in its own way does something to us. Everything has a feel and an essence, whether

that object be seen in isolation or in a grouping of others. We may respond to such visual vibes as are released by our surroundings, or we may turn a deaf ear to their individual tune. But in the end the responsibility is ours, whether we choose to notice or not.

Fundamentally, there is a good deal of plain simple faith involved in the making of a super photograph, a rather immediate response, that cancels out the self-conscious approach. Hence we may work at getting a picture, but if we proceed with too much anticipation of those things that we are about to encounter, then we may miss all those other sights – too normal by our standards perhaps – that were only asking to be photographed. To be open-minded in this sense, and to have a truly receptive eye, means

not to draw conclusions about things and to be open to all possibilities. This is of course precisely what makes photography exciting, the fact that anything and everything has the potential to make a powerful and evocative image.

Our response to the subject of attraction is the choice maker; the adjustment of the relevant knobs and dials of the camera is science. It is important always to be aware of the naturalness of response that brings a great picture into being. Any degree of undue contrivance in the making of an image will be distinctly noticeable in the final picture. People interpret a great photograph as a great photograph, and likewise they recognize a cheap trick shot as just that too. It is advisable never to underestimate people's sensibility to images. If you serve to cater for a low level of image making, then that is all that you will have to be proud of.

Photography is a medium and a form in which one may advance, it is not a limited art. One may set one's targets high in the field of photography, since there is sufficient tensile strength in the still image, and a huge unexplored territory for us to venture into. To discover the less conventional forms of subject matter, in other words those features of our visual world which are considered marginal, remains a wild adventure. It is possible to go the easy way and to produce the photographic image that satisfies all but does nothing, that fulfills its purpose and does its job. You may make money this way, and indeed a lot of it. But it is also possible to set oneself the goal of making the unique picture, absolutely to one's own choosing and no one else's. This should be the more realistic purpose of the creative photographer.

In the search for the superb picture, technique should never be allowed to overshadow feeling and a more immediate response. A photograph can often be seen to fail in its impact because of some obsessive desire on the part of the equipment-conscious photographer to do some little thing. There is no doubt that a great picture hangs always in the balance. What makes the picture good is usually a *fine* point, and not something that it is possible to lay one's finger on easily. If there is an imbalance in the picture-making process and technique begins to overtake the subject by even the slightest, then the photograph will fail. Somewhere, this desire to impose one's will on a natural subject can obliterate its essence and prevent it from telling its own story.

'On the whole' is how we should look and see, and not just with our eyes. To speak even of the 'purely visual' is absurd, implying that it is possible to isolate the activity of the eyeball and our sense of sight from the rest of ourselves. If anything, we should attempt to allow as much of our other person as possible to enter the picture, in order that some humanity should get a look in. In this way the photograph will present us not merely with a readily identifiable subject but with some little part of ourself as well.

UNREAL PHOTOGRAPHY
Fantasy, theatre and ectoplasmic images

On the whole, photography is a medium that is taken very literally. Whether in the field of press photography or of advertising, one is invariably dealing with a 'realistic' image that concerns itself almost purely with the physical facts of the matter. As a consequence, and all too often, little is left open to the imagination. In view of the sheer nature of photography – its absolute reliance on light – the fact that such great importance is attached to the apparent reality of our physical world should come as something of a surprise. We are after all 'drawing' pictures with our cameras, and quite literally so. For as a pen's ink bites into the fibrous grain of a fresh sheet of paper, so light incises and sweeps across a piece of naked film, rendering a very definite impression. Light of itself, however, is a source of interpretation. This is a point that is of considerable importance to the photographer, since it will govern the mood of the image that he or she is making. Hence through the carefully considered and sometimes highly contrived use of light, we may make images that carry a message or make a point in a less obvious fashion.

Light, it should be remembered, can be played with. It can be made to symbolize and create drama, indeed the whole concept of the 'theatre' of an image is one that should be used. Stage-setting with light – in this sense – becomes a skilled and spontaneous art. It obviously needs a fundamental knowledge of the effects of certain light sources under particular circumstances, but pre-eminently it demands a natural and sensitive response on the part of the photographer and a real feeling for the subject.

The photographer Brian Griffin has the nerve to throw light around as kryptonite, bouncing and whizzing shafts of energy. He uses light to convey motion, through the aid of moving lamps. His presumptuousness is well founded in the knowledge and belief that we fundamentally interpret those energetic signals of his, and that everything is not by chance. In his remarkable figure of a man being destroyed, Griffin has drawn a human being straight out of the ectoplasm of his dark studio. The male torso is caught by flashlight, and 'cut off' at the waist through the aid of a piece of black velvet, thus creating the impression of a Greek bust. However, tungsten light also intermingles here, creating motion and a sense of organic life in the figure, and shining in from one side to make a dynamic imbalance in the photograph.

The photograph was done as a double exposure and it should be said that Griffin tends to do very long exposures from time to time. A burning upsurge of tungsten light streams through the body and mind of the man as a holocaust, and a blurry cloud obliterates the head, confirming the total destruction of mind and spirit. There are two themes to the image. One is the destruction of man through nuclear war, and the other is that of Shakespeare's Hamlet. The New Shakespeare Company had originally commissioned Griffin's photograph for a poster of theirs, and the image succeeds in its violent and absolute strokes in achieving the required essence and zeal of a Francis Bacon painting.

Griffin describes his own technique in the studio as 'painting' with light, and he says this without reservation. It should be added that in his photography he happily allows a broad range of influences to have their effect on his image making. Painters play a large part, and he admits that in one of his most successful colour images to date – that of a plump peasant woman poised with sickle in a seething cornfield – the critical balance of light in the picture derives directly from his own observation of the treatment of light in masterpieces of art.

BRIAN GRIFFIN

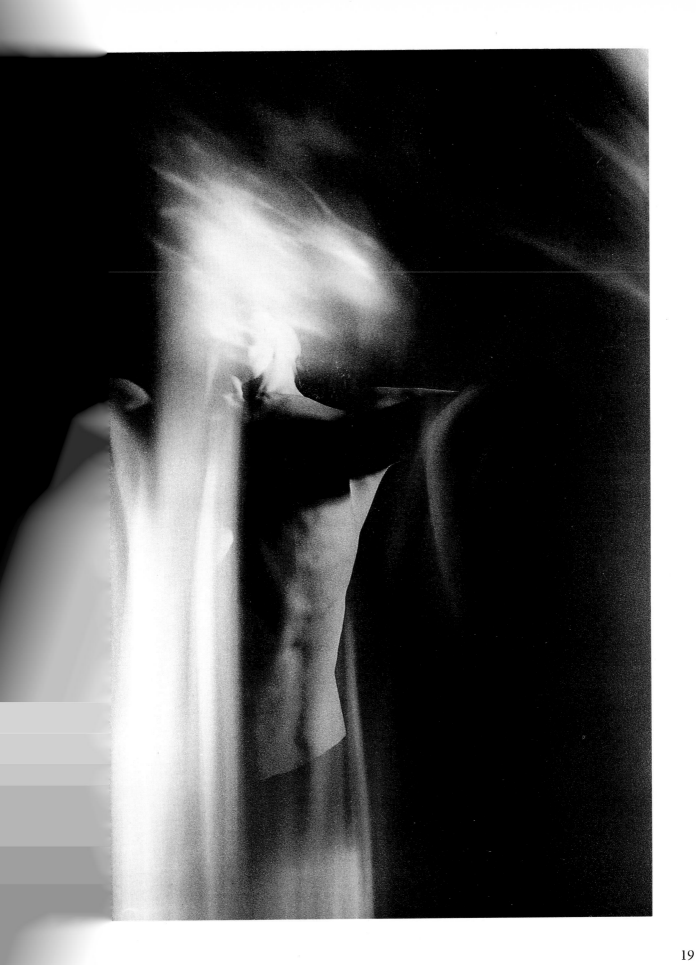

The making of a superb effect in a photograph is for Brian Griffin very much of an occasion. He considers the making of the picture as an event, in its totality. Photography is really not – as many would have us believe – a one-dimensional exercise. For Griffin, the process is an adventure, in the course of which certain amazing things occur, rather than an isolated and incidental moment. We are in effect discouraged from thinking of stills photography as a static and unchanging experience. The studio is for Griffin an astral playground in which bodies and substances blend and metamorphose intangibly and without warning. At the right moment he snatches them from the ether.

We are talking of course about the sequence of an event, or rather a process, to which the photographer has become a witness. It is important to remember that there is a sense in which any photographer working in a studio environment is not ultimately in control of the situation, in spite of lighting and all those other elements apparently within the photographer's grasp. The potential for change in a studio is great, so the photographer who is working in a studio and wants to obtain a very special effect must be open to all possibilities and be very much at the ready. The picture could leap at the photographer before the photographer has a chance to leap at the picture. After all, light, which makes the final image in its various forms, is far beyond one's immediate control, and chance should in all fairness be allowed to play its part.

Flashlight, for example, is not directly visible to the photographer, and so this medium in particular requires a high level of experimentation. For Griffin especially, such a studio shoot is layered, consisting as it does of a great many elements and factors: positioning of the body, in itself and in relation to surrounding space; proportions of the picture; effect that the film format has on the perception of the image. Griffin makes active use of a theoretical rule of composition variously known as the 'Golden Rule' and 'Golden Triangle'.

In very basic terms, this can be described as an irrational proportion or relationship, known since the times of the geometrician Euclid and thought to possess some inherent aesthetic value, a hidden harmonic proportion 'in tune with the universe'. This formula may easily be discovered in most works of art. Griffin explains that a photograph is very pleasing if it follows the Golden Triangle. 'The eye will go from left to right, as opposed to going from right to left. Right to left is very jarring, whereas left to right is very flowing in a picture. If an image is broken into thirds vertically and thirds horizontally, it will be aesthetically pleasing to the eye.'

In spite of all this, however, one is forced to conclude that the larger part of the picture-making process occurs in Griffin's head, and he says that in the end 'the picture is in the mind really'. He has effectively projected the image before himself, as though with medieval rays from the eyes.

It is true that a stupendous effect in a photograph is often due to some spontaneous – if not rash – move on the part of the cameraman. Nevertheless, it is this element occurring in conjunction with a good measure of foreplanning and prior preparation that brings an effective image to its true climax. Many top photographers literally draw out their plan of action on paper before they make a move in any direction. In this way one could say that a certain ground has been prepared, with chance favouring the prepared mind.

Lighting and painting are two separate though interlinking mediums – mutually beneficial forms, if you like. It is therefore especially interesting to find in such a topsyturvy world, and particularly in the work of the enthusiastic Australian photographer Robyn Beeche, a summation of the two in one. Beeche – in her own characteristic and rather cheeky way – likes to fox people a little with her pictures, and of course she succeeds. Her double exposure portrait is of a girl looking at herself in a uniquely flamboyant Stephen Jones hat. But these face-to-faces are so striking that there quite simply has to be a catch, and there is, for this is light painted on with real paint – facial make-up, imitating a certain ideal light that would have been prevailing on a rather bright day. The means to the end of this particular picture-making process were rather complex but logical: in order to imitate, the photographer copies.

The girl was first illuminated with tungsten light, and the shadows were then allowed to fall in their natural place, in relation to the shape of the hat as well as to the features of the face itself. A polaroid was then taken on a Hasselblad and was in turn used as a source of visual reference by the make-up artist Phyllis Cohen. With ultimate refinement Cohen transposed the shadows, as shown in the Polaroid, directly on to the face of the model. The critical result was obtained through a flat illumination of the face with flashlight afterwards, rendering the shadow make-up as if real. Many people, says Beeche, are completely convinced by the whole set-up, although the end result here is much more flattering than would be the case if the illumination had been natural and the girl had been photographed under available light. Pure artifice has proved to be the more complimentary.

It should be added that David Bowie has had his stage make-up done in a similar fashion for a recent video. A level of restraint was similarly exercised in Bowie's image, so that he should not appear too terrifying.

For Robyn Beeche, the picture-making process is quite fundamental in some ways, though by no means less mysterious for all that. For her the image really does come together as the direct result of a substantial team effort. Now it is true enough of course that not all of us have the backing of a Ben Hur film crew, but we invariably have friends and relations, mothers and fathers, people whose opinion is possibly not as photographically single-track as our own. All the extras can be brought in to advance the cause of the final image, even if 'we' the photographer choose to ignore some of their advice.

In talking to Robyn Beeche, one does get the feeling that she is something of a referee, though surprisingly by no means one with a final decision. Where she sees fit to make a compromise in the interests of the success of the final image, she does so. Working with models and make-up artists, designers, painters, and assistants of all shapes and sizes, it pays to keep everyone happy, she says, and the most important part of creating a dynamic special effect in the studio, for her, is to have a good rapport and a comfortable working atmosphere. Such an atmosphere is a major feature of any smooth-running professional photographic shoot.

It is important to consider the amount of back-stage effort that goes into the production of a great photograph, especially since the making of a photograph is popularly regarded as an instantaneous exercise. One moment it is not there and the next moment it is. Beeche's images, it is true to say, often come together after hours of preparation in the form of facial make-up and body painting, not to mention hair styling. In this sense the photographer is working up to an image. Certainly one only has to be a witness on a major advertising car shoot to discover that the critical lighting for the photograph occurs between the hours of seven and nine in the evening, with the sun low in the sky, and this is often after an entire team of photographer and backing crew have waited for the whole day.

All the work above and beyond the actual facts of the finished picture, all the 'extra-photographic' activity, highlights an important point. The photograph does not exist in isolation, and it is a good thing that it should not exist as such. The top still-life photographer Robert Golden confesses to being influenced by things he has read, and a novel about Turkish peasants who through dire need ate raw onions dunked in salt directly inspired him to make a superb image of a knife with salt and onions. Golden even refers to life going on beyond the edge of the frame of the picture. To illustrate the point, he refers to the work of Aaron Siskind, who was a social documentary photographer before the Second World War, and who later dramatically altered his style and his subject matter to a study of the abstract. Golden says: 'I saw a photograph of his — taken about 1945 or so — which in its own way was a sort of still-life, it was a table with a chair against a wall. I felt that this picture was extremely beautiful and very significant, because what it showed was the chair, which had obviously been very well worn and which had been pushed against the wall a thousand times. Hence this referred to the person who had sat in that chair and stood up a thousand times, knocking the wall. And yet again, clearly he had just got up and moved the chair back, knocked

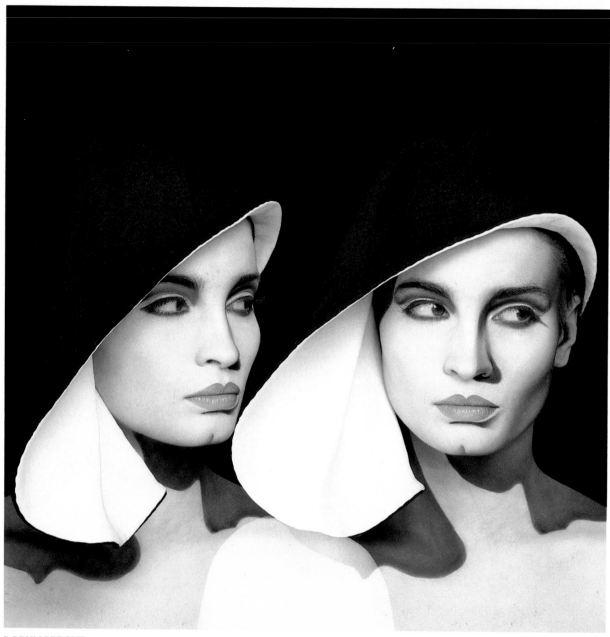

ROBYN BEECHE

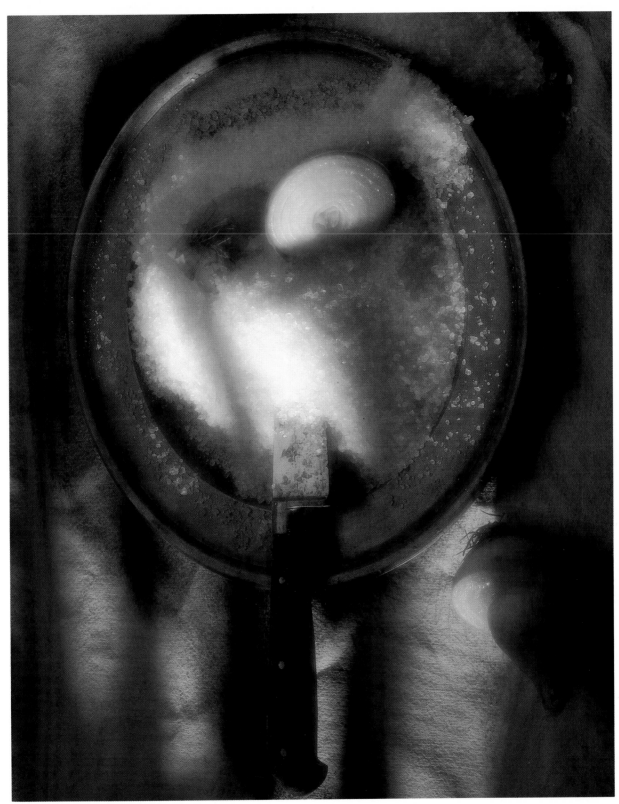

ROBERT GOLDEN

23

the wall and walked out of the picture!' Golden felt this image to be particularly evocative, describing with such a sense of life what it depicted. A piece of journalism, as well as a work of art.

It ought to come as something of a surprise that a photographer of still-lifes should consider – even momentarily – the prospect of life going on beyond the frame of the picture. After all, what could be more self-contained in a sense than a bowl with fruit in it, or for that matter a plate with a knife, salt and onions? Nevertheless, it is for Robert Golden the sense of evocation in his images that causes one to respond in a more total fashion to the picture. This he achieves through a subtle and indeed subliminal combination of elements, and he himself feels that there is a peculiar kind of magic taking place between oneself, the camera, the objects that one is photographing, and light in conjunction with colour. In the end, something results that is far beyond the mere capacity of any of these individual elements; the complete picture is a summation, containing part of the unconscious as well. Golden says, 'So the finished image is in a way outside of you and yet still a part of you. I often see the picture as a great surprise!'

This all sounds rather mysterious, of course, yet Golden maintains absolutely that a picture often goes way beyond his own expectations as the result of a subtle combination of elements. When an effect has been created in this way, he takes note for the future. He is happy that his pictures should give him constant feedback, enabling him to develop his eye further for the future and to build on his knowledge all the time. Frequently Golden's images are suffused with either a warm light or a very cool light, or even a fine combination of both. He speaks about the subliminal effects of certain tones and colours. For him, an all-pervasive hue in a photograph – depending on the nature of the hue – will tend to be either aggressive or regressive, either comfortable or assertive. Blue, for instance, tends to be assertive, and the warm colours tend to be rather regressive – though comfortable. An example of his method of carefully mixing colours of lighting is a shot of a certain biscuit,

depicted in the cool light of afternoon tea. While a rather abstract arrangement surrounds the biscuit in very light tones of blue, the McVitie beckons rather, in its own gentle warmth.

Golden makes considerable use of filtration in his photographs, and he uses it very judiciously. His images are thus invested with a sophisticated soft-focus effect that draws his picture together and gives a feeling of unanimity. As well as this, he tends towards a rather monochromatic representation, with a great deal of chiaroscuro, enabling him to pick and choose the parts of the subject that he wishes to highlight and to place in shadow respectively. Shadow is as important for him in a photograph as highlight, since shadow of itself gives shape and form and volume, and it also creates a sense of mystery – which in turn assists in making the image that much more evocative. The soft-focus effect not only creates a surface unity in his image, but also to some degree obliterates what Golden calls unseemly detail. Certainly, when a photographer works at such close quarters with a subject, depth of field diminishes considerably, and therefore a softness in the image tends to blend foreground with background.

Now that we have spoken of things outside and beyond the frame of the picture, it is of some interest that the photographer Steve Garforth should be among the few who have photographed successfully beyond the grave. His Doctor Frankenstein and the monster is a cinematic masterpiece set up as a still image. The essential quality of the movie exists in the picture, and this appears to have come about, from what Garforth says, in an intuitive way. Having enthusiastically absorbed a sizeable chunk of the styling of older films, Garforth has created a highly charged and relatively complex arrangement from an amazingly simple studio set. Significantly, he chose to use a black and white Agfa transparency film for the shot (a rare medium nowadays), since in colour and tone the emulsion more closely resembles an original black and white movie of the thirties. The idea in this particular instance is to present an image that transmits light, rather than one that reflects it in the same way that a black and white print would have done.

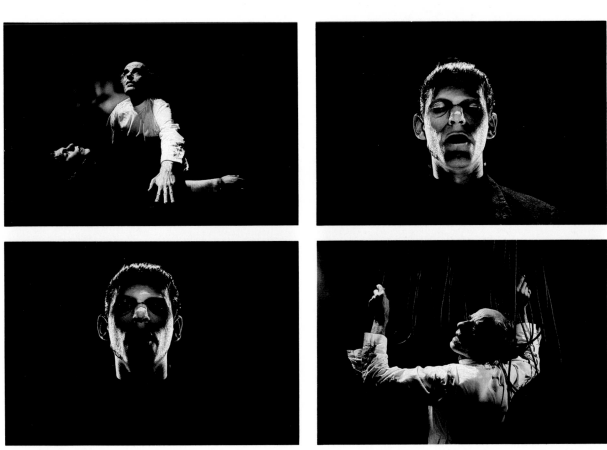

STEVE GARFORTH

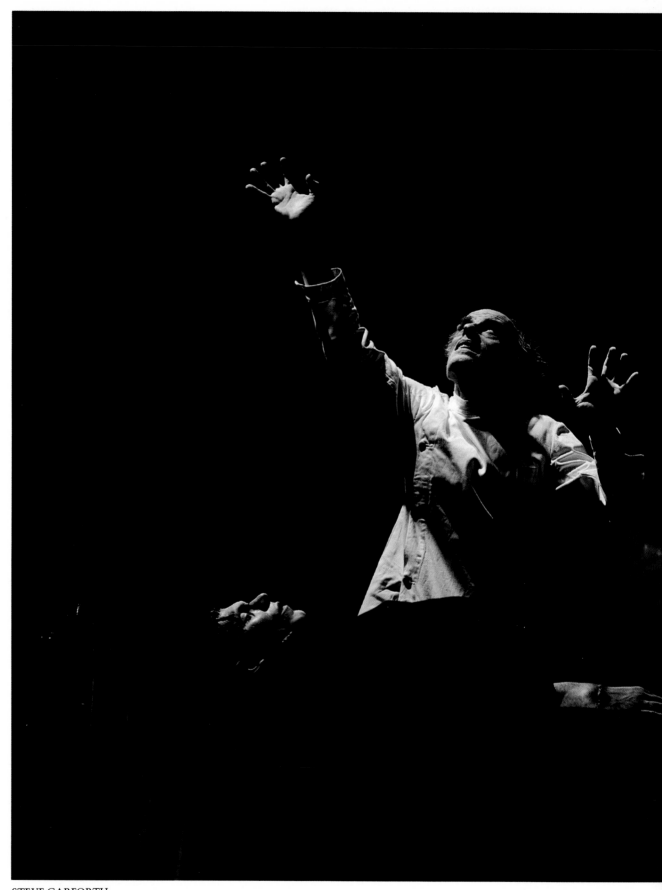

STEVE GARFORTH

The photograph was taken for a video commercial promoting electro-cardiograph monitoring systems. An entire sequence of stills was taken for the commercial, of which this was one. Garforth explains that the image was produced with tungsten light sources from about seven different angles and at a fair distance from the subject, thereby producing an abounding specular effect. All the lights were shielded in specific fashion to the photographer's requirement. Here is a superb example of how light itself can be used as an almost physical substance, moulded, sculpted, and entirely fashioned to create a scene. Here it appears that nothing has been left to chance, and the entire arrangement of the image has been contrived with 'visible' tungsten light sources in order to create maximum drama as the final product.

The sequence of images was animated for television production, which made Garforth's images and the monster in particular come fully to life. The art director had been longing to realize an ambition of his – the role of the monster. So here he lies, with four hours of faultless make-up on him (administered by an ex-BBC special effects girl), and here lies the proof, that contrary to popular belief and irrespective of life's ups and downs, there is for photographer and art director alike, life after death.

THE EVERYWHERE EFFECT
Getting lost in a picture

We have to imagine we are in an almost limitless stretch of open landscape and free air. Here in the sheer tranquillity of a wilderness we may stand with Bruce Brown. He has just stopped his Range Rover after a very long and hot drive through this unparalleled desert, and he has decided to take a picture, largely because right now everything around him feels amazing. This is the serious approach to landscape photography. It is an ultimate endeavour on his part, and one huge search. In order to capture a view at its supreme natural moment, Brown says, 'You're not constructing a picture so much in that sense, you're rather looking for a picture, and there suddenly it is!'

Among Brown's startling vistas are those very places where at one extreme you would shiver to the core at the sheer scale of mass ice floes, while at the other extreme you would be roasted on the spot. He relies completely on nature being unique and admits that he has set himself a hard task. Brown is convinced more than anyone else that you really do have to go two weeks on a dog sled, for instance, in order to get an incomparable photograph of an ice landscape. Taking the picture has never really been the difficult part of the job for him. The main problem has always been finding the picture. Location photography is, by definition, a process of discovery. Having made his discovery, it naturally follows that Brown – with infinite precision and detail of rendering – should transport the viewer to this other world in time and space. This is after all no mere view through a window, but rather a great step into the reality of everywhere.

As Brown himself explains, you quite simply cannot explain in normal terms the true life experience of an amazing sunset. That is something which it is literally impossible to convey. However, with the aid of a high resolution camera, and a film that shows almost infinite detail, one comes about as close as it is possible to come in a photograph to the actual impact and true experience of having stood before an incredible view. Consequently you should be able to feel what it was like to be there. Brown's slightly cleverer than most camera is a Linhof Technorama 6 x 17cm, and he claims that because it sees more 'sharply' than an eyeball, there is greater intensity of impact in the image that it produces. The picture has, as it were, more than you can actually see.

It is important for Brown that every pebble in the picture should be seen, and this is no marginal point. He says, 'The trouble with a lot of photographs is that you can't see what kind of grass or lichen grows in a particular area. This is something that it's important to show, and it's also something that the 35mm format quite simply does not convey as effectively.' The Linhof was originally designed as a scientific camera, and so accuracy was essential. The permanently mounted 90mm f/5.6 Super Angulon lens is 'corrected', and in that sense comes close to the way the human eye sees, especially in relation to perspective. A rectilinear lens, it does not rotate – in the way that some panoramic camera lenses do – and when properly used with its spirit levels evenly balanced, it produces no recognizable image distortion and, most significantly, no curvature of the horizon. All parallel lines are reproduced straight and parallel.

These landscapes of Brown's have been taken at an f stop of 45, quite a minuscule aperture, although in terms of apertures it is possible to go much futher than that. As everyone knows, the smaller the aperture the greater the depth of field in the picture. Here we can reckon that just about everything has been rendered in appropriate focus, with the

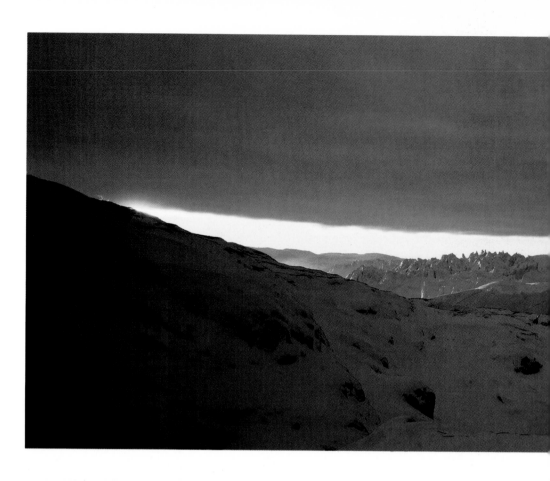

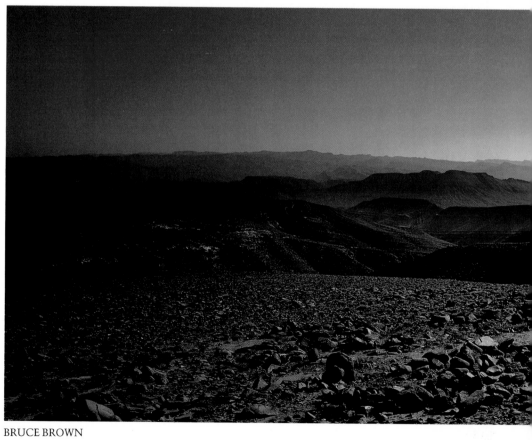

BRUCE BROWN

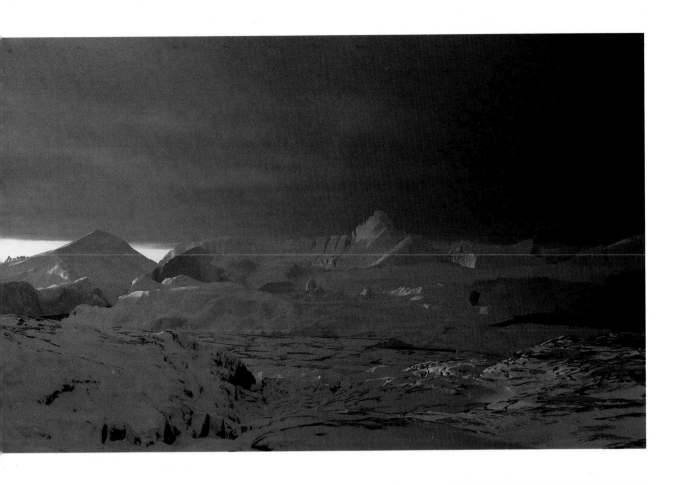

use of a correspondingly slow shutter speed of half a second or slower. At times the exposure has been for as long as eight seconds. Brown uses film that has been balanced for tungsten light under daylight conditions. The film is corrected to 'daylight' through filtration and we shall speak further of this interesting approach later.

Brown, as we might have expected, is an admirer of the great Ansel Adams, and to some extent he follows in his footsteps. 'I really like his approach to photography. He'll drive down the road, see a picture, slam on the brakes, jump out of the car and take it.' This is a refreshing attitude, considering that many people think of large format landscape photography as a long drawn-out process, an endless waiting game. It proves to be more of an event, but while one is searching one is of course primed and ready for this surprise when it comes.

In the case of Brown's own landscapes, he had set himself a task in their production, a reason if you like, a theme. We are back to drawing out the plan of action in that sense. The idea was centred on the concept of population levels, and his choice locations were those that boasted less than a person per square mile. The series of images was suitably entitled 'Population Zero', and he says, 'What you do is you dream up the criteria first and then you run around to find whatever fits.' It appears that he succeeded in that venture, and it also seems that it was a completely three-dimensional experience for him, since he often felt a dynamic purity in the air. 'When you stood on any of these separate spots, you felt good, really quiet, not a sound, very pleasant places. Everything's clean, of course, almost hygienic, but then no-one's mucked around with the place.' Brown's landscapes here, taken in the desolate and overcast frozen wild of Greenland and the sun-scorched and heat-hazed mountains of Morocco, were photographed each in their own high noon.

In another place, and before a view of exhilarating beauty, we stand with Joel Meyerowitz, who has just put his heavy 1938 Deardorff view camera down in the sand, on Ballston Beach somewhere on Cape Cod. He is a little dumbstruck, not having planned to take a picture at all. It was the fluttering of a flag and the encounter with this wonderful white chair – its top just touching the horizon – that stopped him in his tracks. So here he stands, just gazing at the sheer clarity of everything against blue sea and sky, taking in the presence of the place. Gradually, and while a couple of boys and girls piggyback fight over on one side, he opens up his camera and looks into the inverted projection on the ground glass. He can already feel the pressures and tensions, here in this theatre of the view camera.

Joel Meyerowitz's sensibility to his surroundings goes beyond a purely graphic perception of things, and he admits, 'I see what I feel'. Certainly something was happening here, and he says: 'Things were in the process of happening. What you learn with a view camera is a certain kind of patience.' Working with an 8 x 10 view camera, he constantly perceives things as if he is seeing them on the ground glass – a kind of 'pre-viewing' of the scene. 'I used to think that it was nonsense when I read that from Ansel Adams and Edward Weston, but I understand now that it's true.'

It is the experience of a place that is important to Meyerowitz in the making of a photograph. It is as if his senses are attuned to an entire atmosphere, and he says in a most un-photographic way, 'Quite often when I come to a place, I don't see the photograph. I see it as a wonderful place at that particular moment.'

As for his own visual perception of things and his awareness of what is vital and necessary for a photograph, Meyerowitz has no pretensions. If you are convinced by a photograph when you make it, then you can only hope that someone will be convinced by it when they look at it, though not necessarily as art, but rather as feeling. On this point his interpretation is of course highly personal. He says, 'You have to feel what the world suggests as your particular harmony', and he hums an exemplary note. '*My sound*', he adds. Whatever one's sound happens to be, one can take it from him, that's the place to look.

It appears from this that Meyerowitz allows his instincts to follow a very natural course in his picture taking, and certainly things 'take hold' of

him in that sense. It is an act of faith on his part, of course; he allows himself to be spellbound, captivated, and enchanted by these visual encounters.

Meyerowitz, who like Bruce Brown studied painting in his earlier days, is now essentially a 'colour' photographer. You often feel that if you were to raise your hand into the air of Joel's picture, then the pigment would come away like pastel on your fingers. Colour, he says, has an innate meaning for us all, it has an expressive potential residing within it, and one that he very much responds to in his picture making. As well as this, it is very important to him that every element within the frame of his photograph should be absolutely clear and completely in focus.

In order to obtain the required fineness of resolution in his images, he 'stops down' his Deardorff to its absolute minimum aperture of f/ 90. His shutter speeds tend to be anything from half a second to two seconds and over. Life being what it is, things move during that time, and he says, 'Part of what I'm photographing is time, as well as light and colour'. The slowness of shutter speed often invests a picture with a mysterious feel, so that people and objects in motion are either marginally or substantially blurred.

Using his equipment in the way that he does, Meyerowitz produces images that have a certain equanimity to them, and he says that the photographs are meant to be looked at 'overall'. He is after all not trying to hit hard at some single thing in the centre of the frame. The view camera in any case 'drinks in' everything with such equanimity that he says: 'I believe that the viewer can start anywhere in the frame of the picture. Whereas, by the "hook" system which 35mm photography utilizes, you're given something startling and immediately drawn in to see that, while the rest of the frame disappears.'

This broad expanse of picture area in which we may freely roam has not been brought together by a very wide angle lens. The lens, which is known as '10 inch', is a wide field Ektar lens of 250mm and would be the equivalent of a 35mm lens on a 35mm camera (it's about 40mm, to be precise). Meyerowitz says, 'Its sweep takes

in less than our vision, but it has the "feel" of how we see'. Certainly he does not appear to be using an unduly wide angle lens, since there is no corruption of perspective in his images. He doesn't actually like wide angle lenses and says, 'I like to stand at "a distance" from the thing that I photograph, an emotionally correct distance. After all, every space is "charged". I choose to use a lens that allows me to be in harmony with those things to which I respond. A very wide angle lens confuses such issues, just as a telephoto lens does.'

Over the period of 'time' when Meyerowitz photographs with his Deardorff, chance does occasionally stage an event, and he confesses to his own helplessness in the situation from time to time. One of his most mysterious images, a porch with lightning in Provincetown, happened in this way. He had gone outside to the porch because the light was so unbelievably beautiful, a storm had been moving across and it was just before dusk. It was that uncertain time of the day 'between the dog and the wolf' – 'entre chien et loup'. There was still a kind of luminous glow in the sky, and the light of the house was pouring out on to the porch with a great warmth, since it shone through some rattan screens which were a rusty orange colour. Meyerowitz set up his camera, and his calculation was ten minutes at f/ 90. It was during the course of those ten minutes that a bolt of lightning made a lucky strike. He says, 'I would have been just as happy without it, in fact'.

A lucky strike of sunlight against a window seems likewise only to emphasize the weirdness of this Florida hotel, its pool deeply reflecting its every peculiarity apart from the sun itself. This surely must be one of the ugly sisters, and her sense of self-esteem is starkly over-reached by the facts of her monstrosity. Meyerowitz is himself a swimmer and he says that he loves water. Pools by the sea have become a theme of great interest to him and he finds an inherent mystery in that body of water contained, as well as that wild one out yonder. 'Over the last fifteen years or so, I've made five pool by the sea pictures. Now had I really been thinking about it, then I might have made five hundred. But here and there, a pool by the sea emerged as something exquisitely

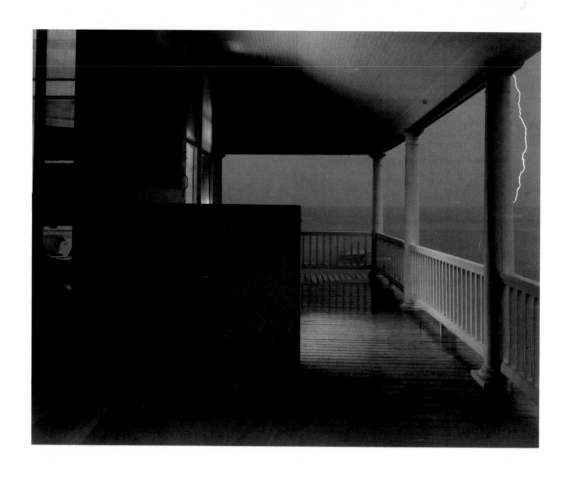

JOEL MEYEROWITZ

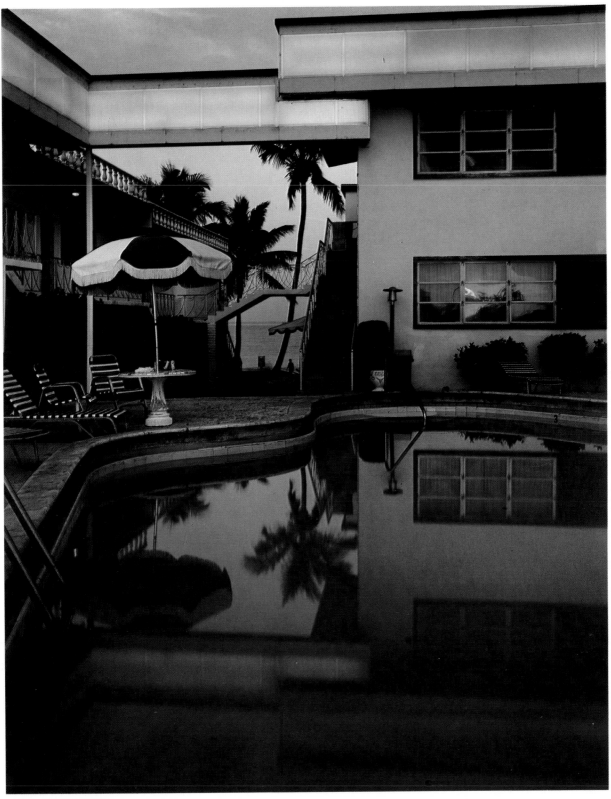

JOEL MEYEROWITZ

penetrating. I believe that photographers are always in search of their subject.' There is a certain kind of symmetry to this image, but one that fights with itself, a strong element of the ridiculous too. One can get quite lost in this argumentative picture, this endless tit-for-tat.

Almost unbelievably, Meyerowitz never uses any type of filter – 'You go through such trouble to get a good lens that reads clearly, why stick a filter in front of it?' He does all his own colour printing now too. The film he uses is Vericolor II Type L (long exposure) negative film, which has an ASA of 100, but which he rates at 80 ASA. The film is actually balanced for tungsten light (and where have we heard that before?). Although the film is supposed to be filtered for use in daylight, Meyerowitz prefers to shoot it straight and then correct it in the darkroom. His prints are made on Ektacolor 74 resin-coated paper. To make a print to his ultimate satisfaction often takes many hours and many printings.

The warmly receding plate of Lake Buttermere is where Geoff Smyth – a photographer with a level of contrivance – has encompassed his effect. This prizewinning shot of Smyth's certainly shows Britain at its most beautiful. Photographed on a Sinar P and Smyth's own 10 x 8 conversion method, he used tungsten film corrected to daylight, a Kodak 81 EF filter to 'warm' the picture, and it is shot on a 120mm lens with an exposure of one second at f/32.

Smyth's picture-taking philosophy is really quite simple in some respects, although his method and approach is undoubtedly more complicated. True enough, he likes the world as it is on the whole, but nevertheless feels that it can be 'helped along' a little bit from time to time, if only from the visual point of view. To begin with, he explains that he very rarely takes a picture at any time other than dawn or dusk, when the light is generally warmer. Admittedly, the light is not always warm enough for his liking even then, and at such times he uses Kodak 81 series light balancing filters. These basically lower the colour temperature of the light and render everything in a more favourable hue, as he sees it.

A commercial photographer without doubt, Smyth says: 'One thing that I have learned is that

people like "warm" pictures, cool pictures are generally considered to be less appealing.' He is aware like the rest of us that the majority of people who use filters do so with a very heavy hand. The use of graduated filters can invariably be seen from a fair distance away and by all and sundry. The effect is quite tiresome.

How does Geoff Smyth achieve his results? One of his secrets is that he almost always uses tungsten film. This is film which by definition has been balanced for use with studio lights and is not considered to be at all suitable for use under daylight conditions. That's how the theory goes, anyway. However, it is possible to use tungsten film under daylight conditions if, like Smyth, one uses a Kodak 85B filter which 'warms up' the light sufficiently to render the scene accurately. Without the use of this filter, a photograph would be extremely blue.

Now naturally there is a penalty for using the 85B filter, and that is ⅔ of a stop loss of film speed. Nevertheless, it is a penalty that is worth paying, says Smyth, since tungsten is superb film, being inherently less contrasty than standard daylight film. Smyth himself often photographs scenes of extreme contrast on tungsten film, scenes which are on the whole beyond the range of daylight film but with which tungsten is able to cope adequately. The detail as rendered in the shadow areas of tungsten film can be quite remarkable at times, according to Smyth. The reason for this is apparently the fact that tungsten studio lights are of themselves a fairly harsh form of lighting and so a less contrasty film has been used to cope with that. Another major point in favour of tungsten film is its ability to cope with reciprocity failure, exposures of four minutes being well within its range. Daylight film, says Smyth, becomes unpredictable with exposures any longer than about two seconds. 'This is no good to me because generally I need very long exposures.'

Smyth's 'Bridge Cafe' is an image which could only have happened in New York. The car in the foreground had been carefully positioned by him to block off half the street. A cop drove by on a motorbike five times, and not once did he stop or interfere with the shoot, and Smyth says:

'New York cops are fantastic. You can do almost anything, as long as it has something to do with showbiz.' This happens to be a favourite eating place of Mayor Ed Koch. Smyth was attempting to establish a certain distinctiveness of style in his New York pictures at this time, and he admits that a good deal of planning and forethought had gone into the production of his images over that period. The shot was taken on a Sinar 5 x 4 with a 75mm Super Angulon lens with 85B and 81C filtration. Tungsten film was used, of course, and the exposure is 2 minutes at f/32.

The whole point of a great still-life image, according to Smyth, is that it should look as if it's doing a hundred miles an hour in all directions. The eye should be kept on the move in the picture, and one's vision should dart from one point to the next in quite a haphazard fashion. The eye should pick up certain key lines in the picture and follow those lines within the image. Smyth says, 'We put a rectangular frame around a picture, but in fact the action comes from diagonals within the area of that frame'. He admits that he learned many of his lessons in 'dynamics' from his one-time master Bruce Brown, whose product photography frequently uses the power of strong diagonals to lead the eye inevitably to a given point in the image. The source of Bruce Brown's knowledge almost definitely comes from painting, one should add.

Smyth himself says that whereas painters, wishing to depart from a 'normal' perspective, could use their own imagination, photographers may instead use wide angle lenses in order to emphasize and if necessary strengthen certain diagonals and a given perspective. Nevertheless, it should remain possible, with the careful management of a wide angle lens, to produce an image that is not all too apparently a 'wide angle' shot. Even Giotto might have enjoyed using a Sinar and a Super Angulon, with heaven and earth in perfect perspective, and all on one sheet of film.

It can safely be said that Smyth's Bridge Cafe in New York has sufficiently etherial qualities, and the dynamics are there for us to see. The car in the foreground contains and balances this almost entirely engineered picture. It is, as it

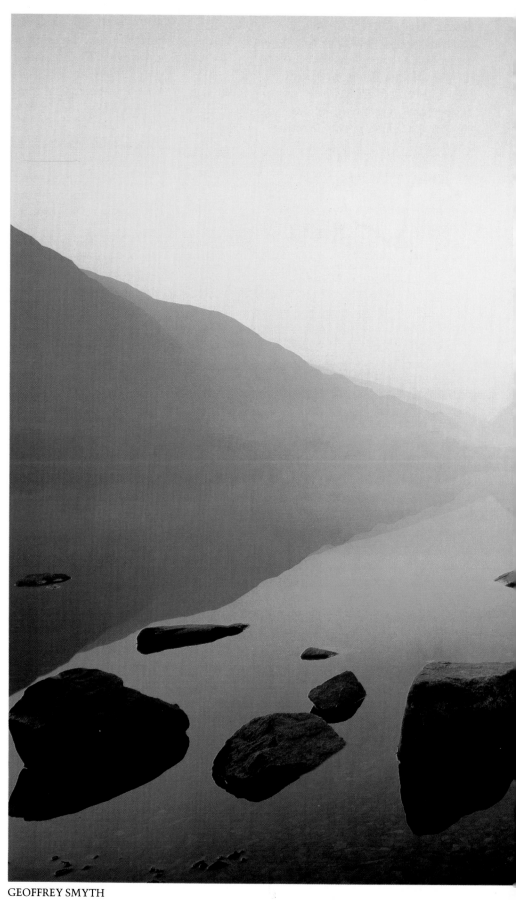

GEOFFREY SMYTH

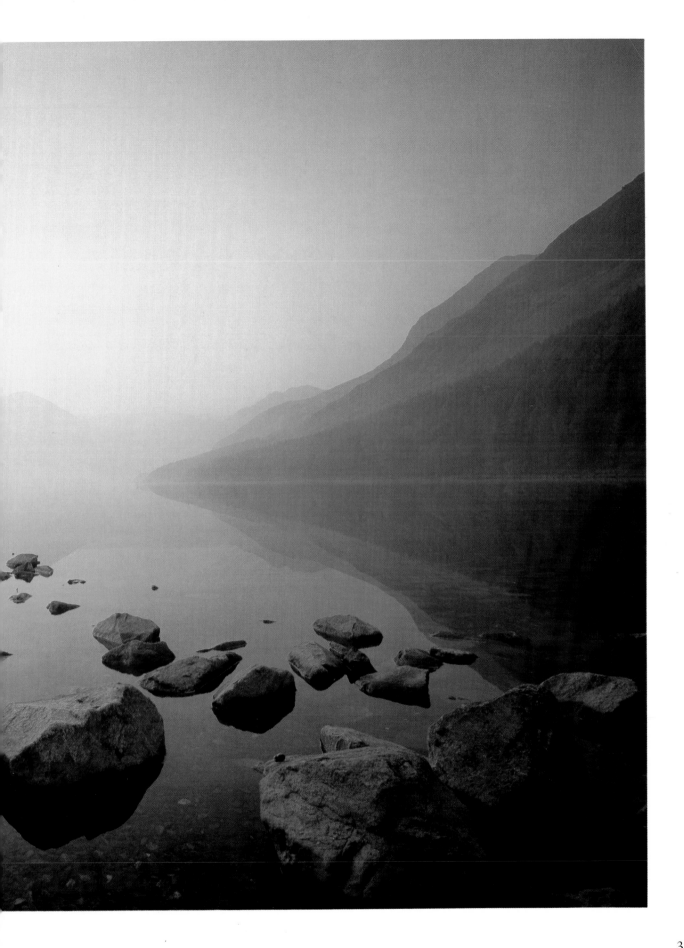

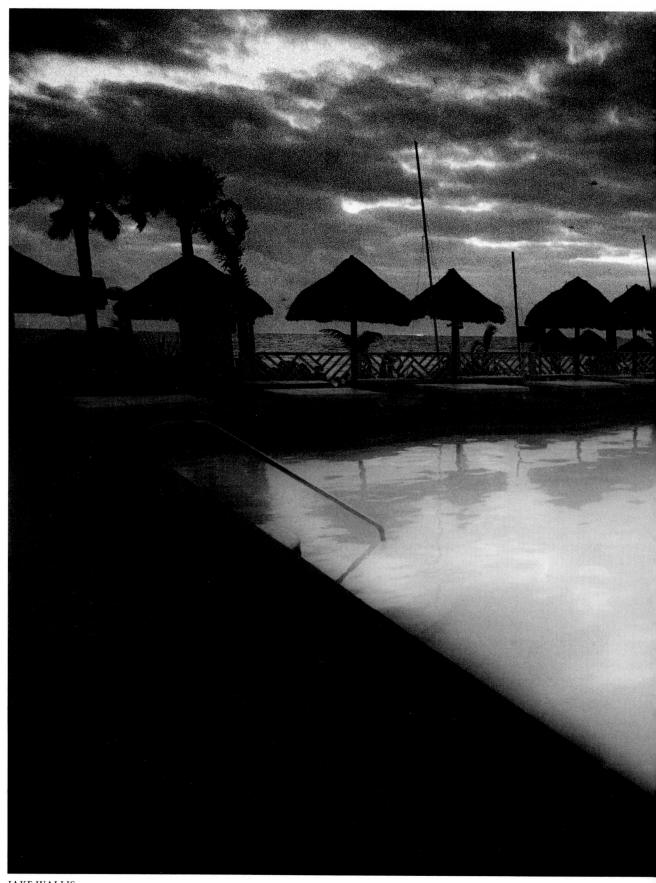

JAKE WALLIS

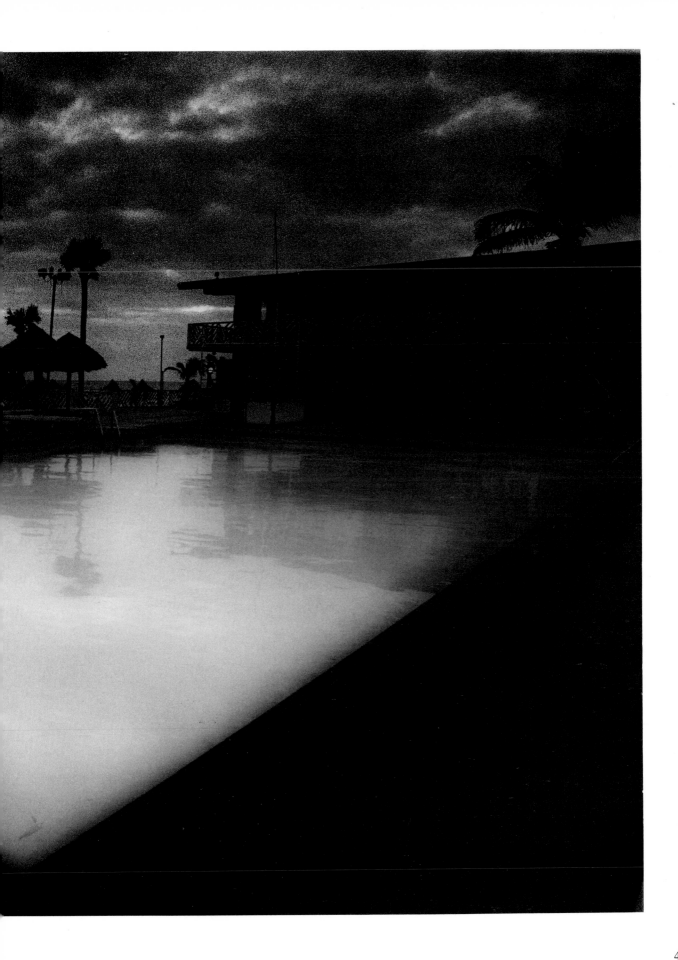

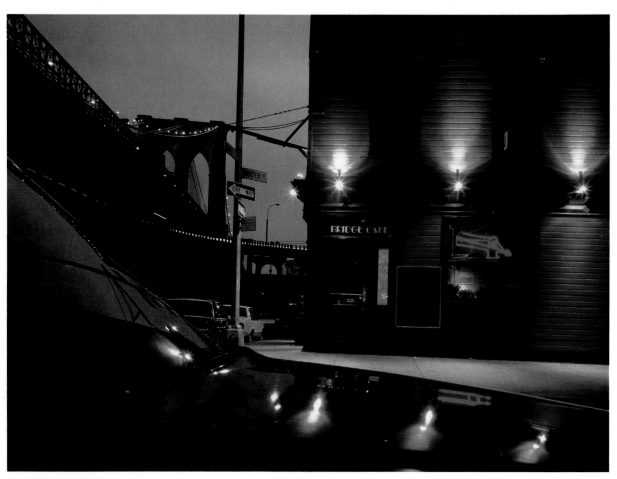

GEOFFREY SMYTH

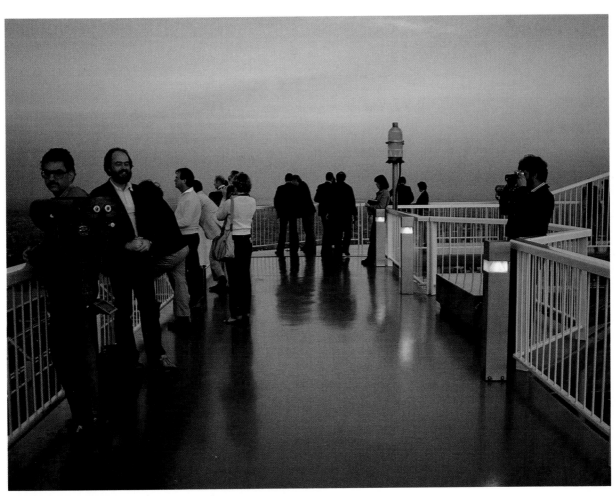

ROBERT HAAS

were, a self-supporting act. A strong diagonal line runs from the top left-hand corner of the photograph downwards along the line of the bridge, and across towards the little red sign in the restaurant window. The strong diagonal of the car runs in sympathy with this and plays along with it, so to speak. Yet the picture itself is in some way chopped in half, since the cafe occupies almost 50% of the picture area, which in strict compositional terms should not be allowed since the image does not obey the rule of division by thirds. However, the image succeeds, it functions, and we can only suspect that the strong unifying effect of the diagonals is the major cause of this.

Another swimming pool, this one open to the heavens, freely invites us to become a part of its mysterious phosphorescence. We have the feeling that we would disappear into another world altogether if we were to leap into this well of uncertainty. This is a pool by the sea, one should note, and it is evident that Jake Wallis – who took the picture – responded rather like Joel Meyerowitz in his choice of subject. For Jake, film of itself tends to be rather too sharp from time to time, and so he likes to bring about a softening in the image that he makes. He does this in the darkroom, and to his own personal specification. His swimming pool is a fair marathon of a darkroom effort. In fundamental terms, we can say that the picture was exposed for 10 seconds, while the pool area itself was blanked out. The entire picture area was then exposed through a perfectly ordinary transparent polythene freezer bag, and for a further 10 seconds. The sky area was then exposed for a further 20 seconds, but without the aid of the freezer bag. After this, the corners of the picture were 'burnt in' for a further 10 seconds or so, giving the image a vignetting effect that draws the eye towards the centre of the picture area. The photograph was exposed at f/8, and printed on grade 2 paper. Jake took the picture off the coast of Florida at dawn.

In talking about swimming pools, we are of course not merely discussing them as a case of potentially interesting subject matter, but rather as a supreme example of the 'play' of light, the game that it has with us. Indeed we are talking about those very 'swimming pools of light' that surround us and confront us almost everywhere

we go. I can best prove this through my own picture, taken about as far from level ground as it's possible to get without the aid of wings, at a quarter of a mile in the sky – the rooftop 'promenade' of the World Trade Centre, New York City.

Now as Jake's strange little thatched parasols appear to reflect ominously in his Florida swimming pool, so do these figures which I saw, bouncing themselves off the floor. At such an odd spot, everyone – or practically everyone – was looking elsewhere and so the situation seemed made. Having had a long talk with Joel Meyerowitz only a few days before, I think that I became a little attuned to his way of seeing, without knowing it. I knew that I had the wrong film in my otherwise quite finely resolving Leica M3. The film was fast and grainy, and I had a feeling that the colour was going to go adrift as well. So having had this strange encounter, I made a quick decision to descend one hundred and ten storeys to buy one roll of Kodachrome 25, and then made the return journey in this perfectly seasick-making lift. When I arrived I found that the light had become richer in the meantime. I framed up everything as best I could, waved frantically at the awkward man on the left to stop looking at me, waited for the red light to flick on – since it flashed at a slow pace – and tried to include as much as I could of all that I liked. The aperture was naturally set to f/16, and my shutter speed must have been about 1/30th of a second. I think that the picture has a little bit of everywhere, and I was certainly all over the place when I got it back from Kodak.

It is interesting to compare Geoff Smyth's view of Lake Buttermere, Jake's Florida pool and my own roof-top shot. All three of these are related in their dynamics, they have as it were the same plan of action. For this to occur in three separate and unrelated images is something of a miracle. However, it does illustrate how we instinctively respond to subject matter, and how angle and point of view do determine to a large extent our choice of subject, no matter what that happens to be. Now to delve into the full mystery as to why and how these things should happen is undoubtedly something that is worth doing. But for present purposes it should be enough for us

merely to gaze at this open-air threesome and allow ourselves to get lost in them. After all, the photographer placed his faith in the taking of the photograph, and it is only reasonable that the viewer should venture likewise.

To celebrate a really special effect, we go to Geoff Smyth's masterpiece of pyrotechnics, his hundredth anniversary of the Brooklyn Bridge. We realize immediately that Smyth must have spent a long time choosing his most superior vantage point. With plate glass windows specially removed, he shot the event on a Sinar 10 x 8, and on a 5 x 4, as well as three 35mm cameras, all of them personally operated. The exposures were for four minutes, and the display lasted for half an hour. As the rockets soared and sped, and their trails incised across Smyth's waiting film, his fortunes changed and shot to dizzy heights.

Contrary to popular belief, for an effective firework picture one has to use the slowest film possible, and a long exposure. Smyth's exposure was for four minutes at f/16, and he shot the spectacle on tungsten film corrected to daylight. The film was pushed one stop to assist with contrast. For the image shown here, Smyth used a 210mm Angulon lens on the Sinar 10 x 8 format. Anticipating that the light would be measurably more intense at the very top of the bursts, he used a gelatine one-stop neutral density filter to 'hold back' the light above the line of the horizon.

This is a photograph that has been painted with fire. The long exposure has enabled Smyth to capture a series of firebursts over a period of time. This scene as it appears never existed at any one moment. It was rather 'built up' over the four minute exposure time. It is therefore really a four minute movie on one sheet of film. Smyth is slightly proud to admit that it was taken on a borrowed camera. But the real lesson of this fiery exercise is that he was ready and prepared for the event, and of course it all happened for him, and beyond his wildest dreams.

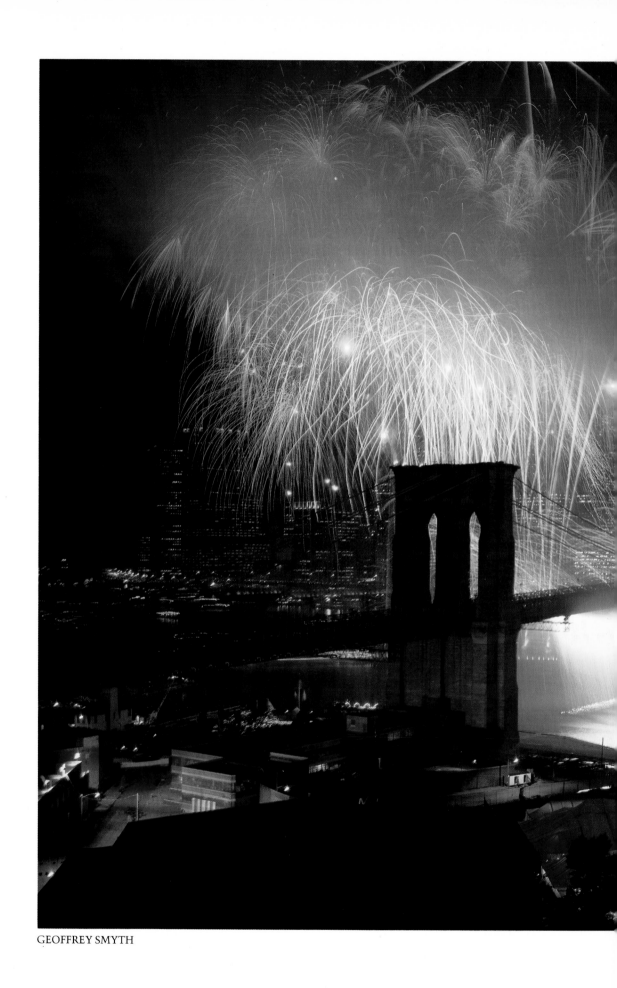

GEOFFREY SMYTH

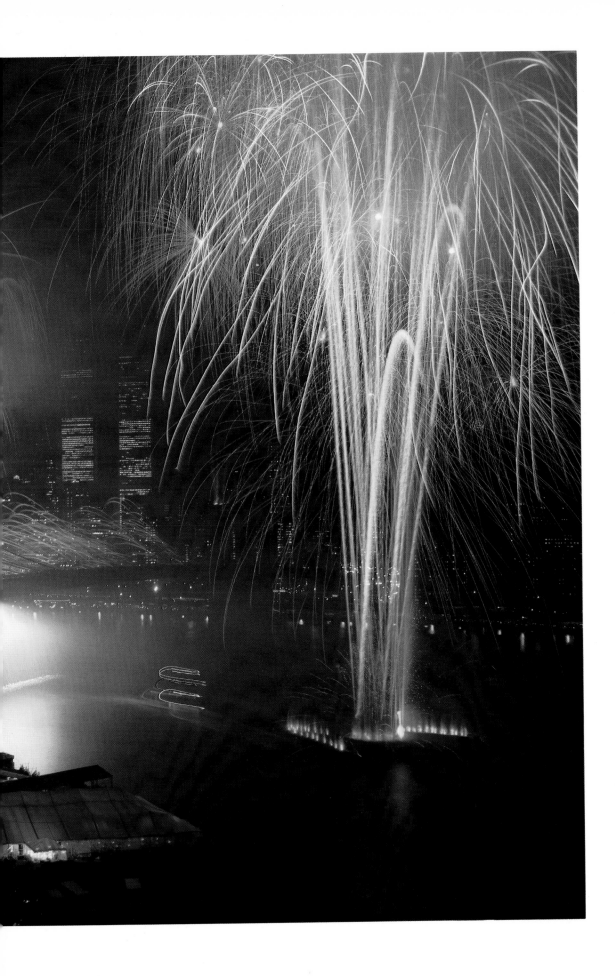

THE FLAT EFFECT
Pictures with little or no depth

In a certain sense it is true to say that in photography everything is legitimate. Photography records and reflects the fundamental and the plain, as well as the complicated and sophisticated view of life. Were this not the case, then perhaps our world would be over-stressed with rather heavy and 'loaded' images. Fortunately our senses attune readily to the simple point of view, the single statement rather than the detailed phrase. We respond in an interestingly immediate way to certain images, as if there is some built-in mechanism, some intuitive light switch that tells us 'this is nice'.

There is no obvious reason why a piece of sidewalk garbage should have thrown Irving Penn back in his tracks, except that this barely surviving seven of spades – when blown up to Herculean proportions and printed by the platinum photographic process – takes on the aspect of a rare and striking piece of tapestry. As if on some ancient fossil, the signs of the spades emerge just sufficiently from the decayed and broken down surface, begging for our attention and causing us to work a little. After all, had urban nature further followed its course, and by just a twinkling, then this playing card's identity – already on the brink – would have been lost for ever. Penn has caught it in the nick of time and from dust to dust. Objects such as this, photographed in this most particular way, tell us something about the nature of our physical world, without over- or under-stating the case. In a sense it is merely a representation, a photograph that in its own way tells us something of how we feel about our surroundings. Its message is a purely graphic one, a distinctive form of social documentary.

Penn appears to take a certain delight in the materials of the platinum process and he seeks out subject matter that will best take advantage of the medium's possibilities. In his 'Camel Pack', nature appears to have encroached on a universally recognizable and distinctly American symbol of civilization as we know it. Here too there is no contrivance of the subject, no 'posing', but rather a simple recognition and rendition of what already exists. This was doubtless no desperate search on Penn's part, but rather a plain encounter, a feature bumped into. Grasses and feathers penetrate and wind around the familiar cigarette packet design, and every detail is picked out intricately by the platinum metals. The resulting design is a lyrical orchestration of tones and textures and contrasts, encountered accidentally and recorded definitively. Here is sufficient meaning behind the purpose.

A platinum print by Penn is extremely valuable, for it involves a large amount of craftsmanship. The platinum process is a detailed one, adapted and extended through the use of contemporary industrial materials. Prints are made by contact exposure and are usually done from enlarged negatives. The prints themselves are made on various papers which Penn hand-coats. The sensitive coating contains salts of platinum metals and is brushed onto the paper, which when dry is exposed under the negative to a strong scenon light. Exposures can vary from several minutes to two hours or more. Development of the image takes place in a solution of potassium oxalate. Subsequent etching away of residual iron occurs during immersion in several baths of weak hydrochloric acid water. Finally the print is washed. The finished image consists of particles of metallic platinum and palladium caught in the fibres of the paper. More detail, however, is to follow.

Some of the prints are made in two coatings, each of different combinations of platinum and palladium (and sometimes iridium). In such cases

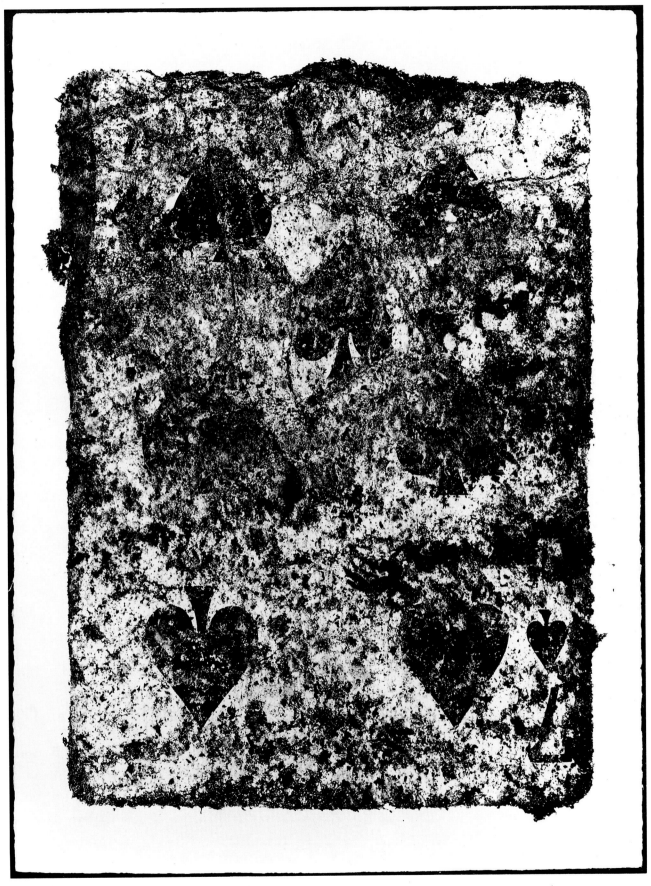

IRVING PENN

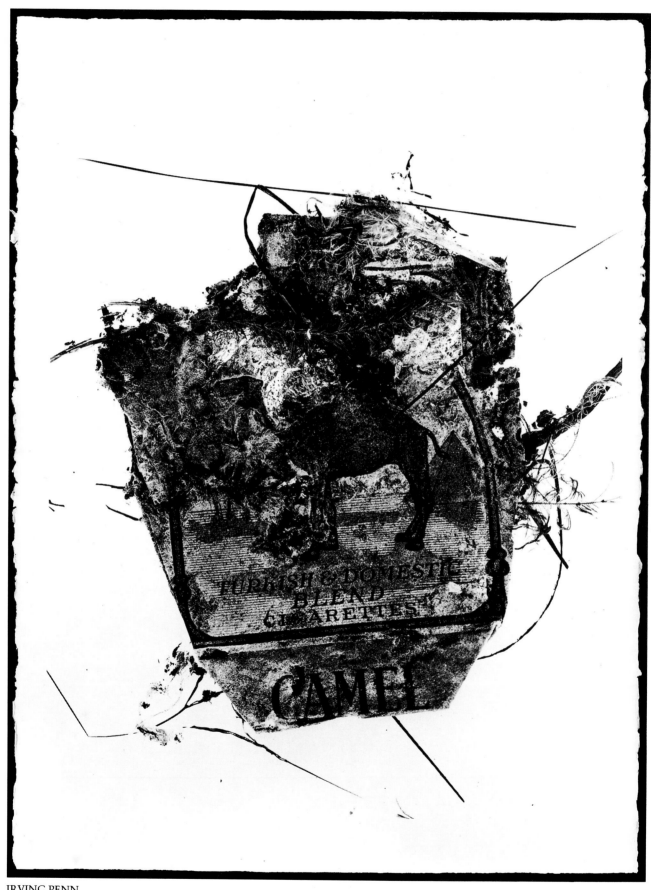

IRVING PENN

50

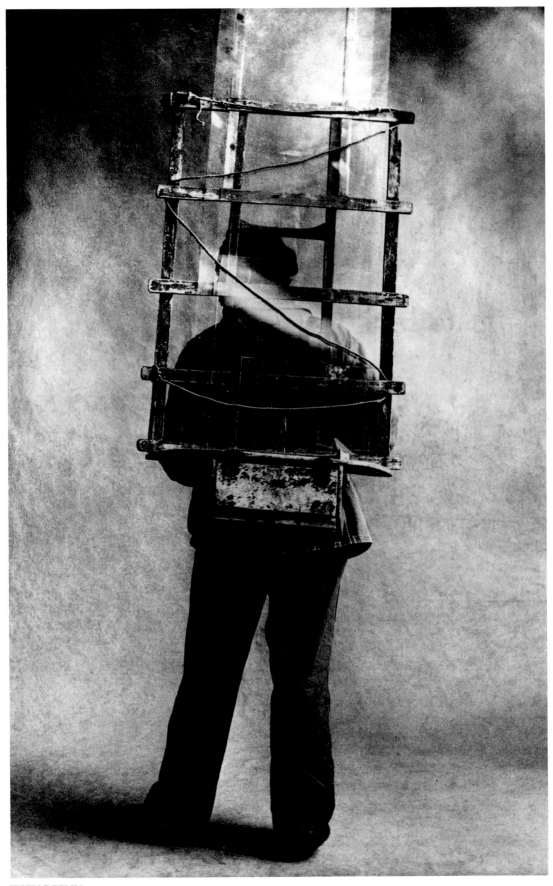

IRVING PENN

ROBERT HAAS

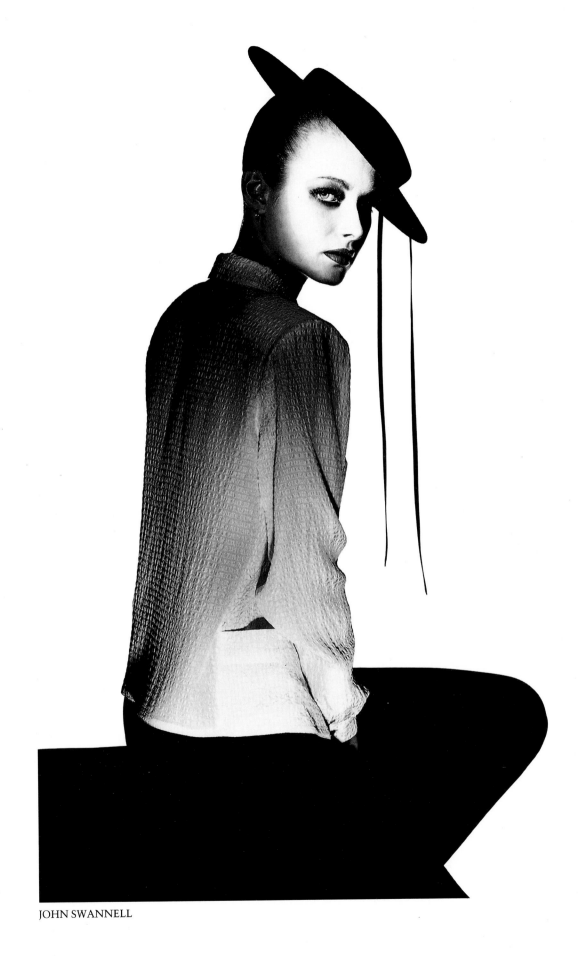

JOHN SWANNELL

there are usually two or more negatives of varying contrasts used in making a single print. Registration of the several exposures is made possible through the use of dimensionally stable estr-base films and a system of precise punches. Dimensional stability of the paper is achieved in joining it to a sheet of aluminium by fusing a layer of thermoplastic between the metal support and the paper. The resulting sandwich can endure repeated wettings and dryings with little change of dimension.

Among the many and varied subjects that Irving Penn has tackled as a master of almost every sphere of photography, there is that series of images entitled 'The Small Trades'. These are the less famous of Penn's personalities. The photographs show tradesmen and women of London, Paris and New York, all bearing the tools of their trade. They stand as individuals or couples, isolated from the natural context of their working conditions and brought into the pearly illuminated other world of Penn's North light studio. Those featured are a knife-grinder in Paris, a couple of charwomen in London, a New York welder, and many more – a seamstress, a policeman, a butcher, a baker, a carpenter – a whole gallery of them, all subject to Penn's minute scrutiny. Amusingly enough, while he was working on the series of pictures in New York, he had difficulty in convincing some of these tradesmen that they should come to the studio just as they were, and not make any special changes. Many wanted to go home first in order to change into their Sunday best.

Out of this extensive series of images of the small trades, a theme which is also a part of a certain tradition in painting and engraving, there is one image that jumps out as being one of the most mysterious and awe-inspiring in the history of photography. Penn's Vitrier – photographed in 1950 with the rest of the group – is a creation of the most haunting intensity. This effigy of a Paris glazier poses all questions and offers no explanations. This is a figure of utter anonymity, with his back to us, and a cage-like structure apparently containing his upper body as if portably imprisoned. Or it might be a sandwich board with nothing to say. The sheet of glass in its frame reflects ominously.

Penn, by now a legendary figure, is another one of those photographers whose original intention had been to be a painter. Indeed his portraiture is believed to owe much to the Dutch masters. In his portraits most especially, Penn's unique and characteristic lighting is distinctly un-photographic in its nature. He has been accused by his harsher critics of doing with the camera what should be left to the brush and canvas. Nevertheless the fact remains that Penn chose the photographic medium, though we are reminded how incidental this decision was on his part.

Having made portraits of a great number of very famous people, Penn proves himself in the field of portraiture – as well as in the innumerable other aspects of his work – to be a highly sensitive individual. There is a type of extra-photographic awareness with him, one that appears to go totally beyond the so-called 'purely visual' perception of the subject. Already this very phrase has become rather a joke, since it implies that the activity of the sense of sight operates in some form of ridiculous isolation. Penn is, for instance, acutely conscious of the need to know something about the work of the person he is making a portrait of, and he regards this as a vital ingredient for a sitting. This may involve knowing the work of a writer or painter that he is about to capture on film, or even having seen a dancer perform. From Penn's experience, the sitter can sometimes be quite overwhelmed if the photographer knows some little thing about the professional life of the subject. In Penn's own words, 'In a creative person, the fabric of self-belief can be very thin and easily damaged'.

Penn speaks of the camera with a peculiar respect. 'I have always stood in awe of the camera. I recognize it for the instrument that it is, part Stradivarius, part scalpel. I am not at all tender (I think of myself as neutral) as I seek to make an incision in the presented façade. I do not think this is cruel. Very often what lies behind the façade is rare and more wonderful than the subject knows or dares to believe.' So here, amidst the harsh mechanics of the camera, we have a highly conscious mind, and a positively electric exchange occurring between the photographer and his subject, and almost without the subject as much as knowing it.

Whilst working in New York, Penn has used a large view camera, a wide bank of electric lights, and a heavy tripod. When travelling he has used a Rolleiflex – a camera to which he is devoted – a light tripod and the light from the nearest window.

Irving Penn has said, 'The photographic process for me is primarily simplification and elimination. It's that simplification that I need in a picture that really relates more to old painting and old sculpture.' The photographer John Swannell – a great admirer of Irving Penn – has produced an image of the most striking simplicity. He feels that much of the picture's style has been influenced by the renowned Horst P. Horst and particularly by Horst's apparently simple though frequently complicated lighting set-ups. The clothes in the Swannell picture were designed by Jasper Conran, although that is almost beside the point, since the overall effect of the image overrides any considerations of fashion. This is not just a fashion picture. Swannell used two spots to light his wife, Marianne Lah, and had the background completely bleached out. Clothes themselves tend to dictate the way that the picture is made, says Swannell, and in this one can only exercise a certain amount of control over the subject. Unlike Horst's pictures, Swannell's images are often – as with this one – shot with flash. That can likewise make for an interesting atmosphere, especially to the untutored eye.

On a studio shoot with John Swannell, one is literally surrounded with lights beaming on beams and flats being placed and replaced. The sheer amount of paraphernalia seems to contradict the making of a sublimely simple image. How is he going to get a picture of just her in the midst of all this stuff? What about that line in the background? 'Oh, you won't see that,' he says. So he knows what is going to be seen and what is not going to be seen. Swannell has worked quite a lot with natural daylight in the studio environment. He sets himself a difficult task here and admits, 'Shooting under available light, everything works against me'.

Swannell uses an exceptionally slow film, Kodak Panatomic-X, with a rating of 32 ASA for his black and white photography. The reason for this is because he dislikes the effect of harsh grain in a photograph. 'When you're photographing a girl's skin, this film reproduces exactly what you see, that fineness. When you put grain into it, it becomes "photography". To me grain is photography, I'm not interested in photography as such, I'm interested in the image and making the woman look beautiful.' It naturally follows that Swannell's field of focus is extremely shallow and that his focusing is really quite crucial. His exposure is frequently between a 15th and a 30th of a second under daylight conditiones. Now this would be tricky enough on a 35mm camera under the circumstances, but a Pentax 6 x 7 or a Hasselblad and its heavy mirror can cause havoc with vibration at those speeds. Swannell solves the problem by suspending a container full of water from the underneath of the tripod, thereby holding it rock steady.

As a final point of interest in the John Swannell photograph shown here, it should be noted that the facial make-up was made particularly strong in order that the concentrated light beam – controlled through the aid of a snoot – should not bleach out the face.

And so we go from one kind of bleaching to another. We have seen how a face has been accentuated and encouraged in its three dimensionality in Robyn Beeche's shadow make-up. It seems only reasonable therefore that after a visage with as much jump-out-ability as a jack-rabbit, her other most notable image of a face should be as flat and as even as a piece of parchment.

This positively 'pressed' picture of Beeche's is again a combined effort on the part of herself, make-up artist Richard Sharah, and designer Willie Brown. The photograph, which was designed as a 'look' for the eighties, evolved in a rather spontaneous and ad-lib way, as do many of Beeche's images. This happens also out of a certain necessity, in that when Robyn Beeche works with hair, make-up and clothes, no one element can be allowed to overshadow the other at any time. The picture was commissioned to promote Willie Brown's collections, which are very much of the 'New Wave'. It so happens that Beeche and Sharah were working on the concept of Letraset make-up at the time, and although

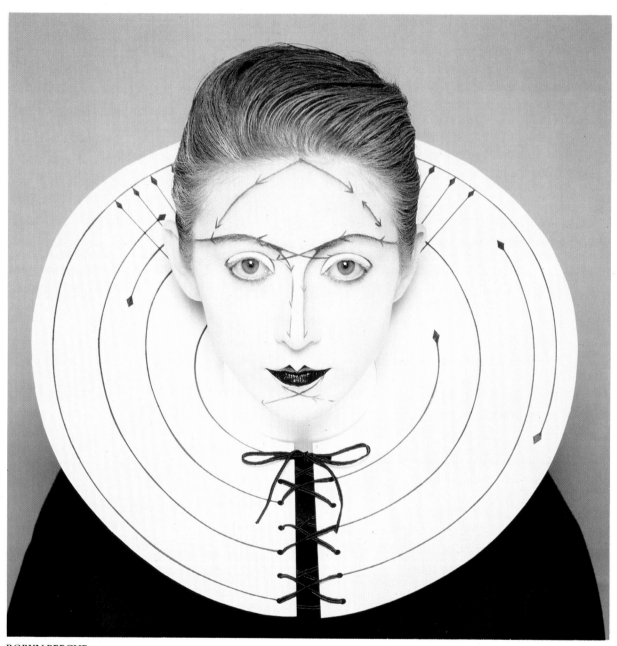

ROBYN BEECHE

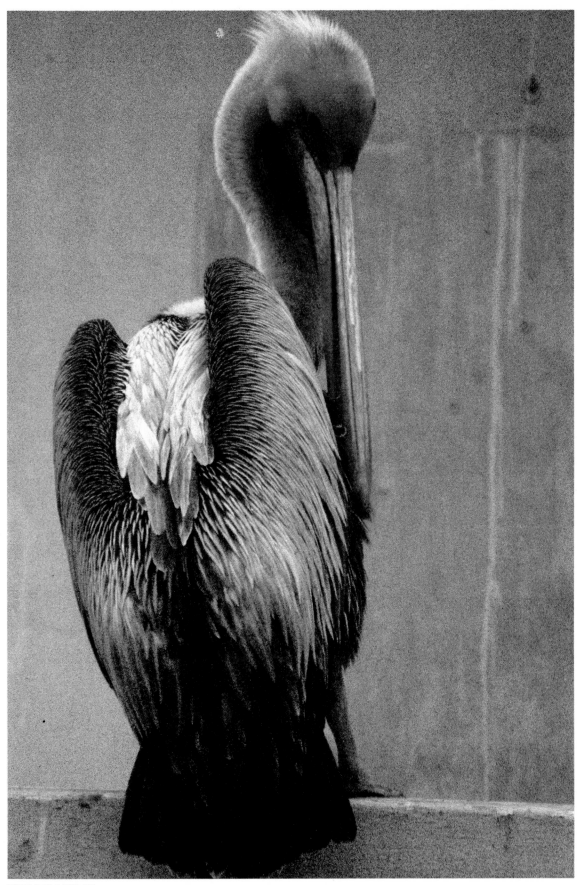

JOHN CLARIDGE

they decided against using the figurative medium, it is plain to see that this printworthy system has crept into the creative process somewhat apologetically, and through mere suggestion. Willie Brown designed the collar on the spot, to accompany, complement and frame the face, the inspiration being that of an Elizabethan ruff.

Beeche's intention was that the photograph should appear to be as much like an illustration as possible, its monochromatic qualities making it all the more striking as a colour picture. She also says that in order to create such a 'taken-away' look, it is necessary to over-expose in the camera and then to 'push' the film in the processing, these two factors working in conjunction and so contributing to a general loss of depth and form in the face. If the make-up is strong enough, then it will of course show through this process. 'Why not flatten pictures?' says Beeche. 'After all, you still have to know about depth of field, so that you can get your ears and lips together in one shot. The same rules apply if you want to get it all crisp.' She also emphasizes the difficulty of getting an even white surface where most images of white faces appear blotchy by comparison. Her use of square-shaped flash heads caused an eccentric activity in the pupils of the eyes and a faintly robotic gaze.

It must be a strange sensation when John Claridge is beaming his 500mm lens at you and thinks that you don't know. This lovely muted bird, from some lesser part of paradise, this pelican per se standing poised and with sufficient pride. On a dockside in Salvador, Brazil, is where Claridge caught the creature in its flat featheriness. The lens that he has used has given Claridge's image a highly appropriate perspective, especially for a photograph whose subject prides itself on its texture. Human beings may be philosophical, while birds – the wise ones – are texture-conscious. The soft background of the picture blends perfectly with the photograph's subject, and this is just as well, but then of course Claridge as a master 'portraitist' has done other things to it. He used 35mm film, up-rated from 400 ASA to 1600 ASA, so that the grain in the image appears to have increased, and as a consequence the contrast in the picture has been reduced, resulting in these wonderfully

comfortable pastel shades. The 'pushing' – says Claridge – can only go so far, however, since a photograph begins to verge on the monochrome if one gets too ambitious with speeding-up film. Hitting the vital balance and knowing when to stop seems to be the lesson of the exercise.

This is no mere messing around, though. Claridge's eye is sympathetic to the subject, his management of fast 35mm film – subsequently blown-up to the 10 x 8 format – has allowed this bird to reside in an imposed texture too, and one that the film itself has provided. Yet the pelican stands out quite sculpturally from its background, hence it is not over-absorbed by its own medium. But then Claridge says, 'The camera shouldn't get in the way of a picture, it's after all just another instrument to put together how you feel about something'. It certainly seems that his feeling for the beast came first and the snap came later.

From colour with reservation, to colour as the incidental and completely unexpected, yet bright. I met these odd little cards and their pop colours on the Greek island of Naxos – one with an African atmosphere, funnily enough. When I first noticed them I found it a bit peculiar that they should be there at all, and that they should leap forth so from this historically docile backdrop, like dancing girls or something. Without going into the mumbo-jumbo of it (and indeed this is something of a witch-doctor picture), it is true to say that isolated colour does funny things. But then again, these dinky hairclips, picked out as they are in their own cuneiform across this yellow frieze, do spell out some visual message, as if for the eyes of one fresh from Alpha Centauri, a set of instructions to be fatefully followed. These cards have of course nothing to do with the weatherbeaten and whitewashed wood and stone before which they hang, they are a natural contradiction, and I think they celebrate the fact quite nicely. The photograph was taken without complication on a Leica with an ordinary lens, whilst I allowed for as much depth of field as possible.

With wild abandon beyond the apparently flat plane of the picture, David Fairman has made his somewhat bigger splash in a Manhattan cocktail and by positively throwing his stuffed olive right into it. It was the only way that worked. The glass actually had to be quite a large one for the purpose. The background of the picture was built up of pieces of curved plastic receding away from the camera and in sequence, hence their tops are seen to darken as if in a landscape. Fairman's image has a most distinctive grain quality which he will not explain in detail, since he says that it is all done in the dark.

No filtration has been used on the picture, which was blown-up to the 10 x 8 format from 35mm. The ASA of the film was relatively fast but considerably up-rated and the photograph was taken with electronic flash. Fairman admits, however, that this was no fluke, and that the effect involved about three days of effort in all. 'We tried rolling the olive a number of times,' says Fairman, 'but we discovered that the best thing was to fling it.' One of the more adventurous ways of advertising gin, without using the colour green (it was in fact used as an ad for Beefeater Gin), the image succeeds to a very large extent owing to the pointillistic refraction of the colours of the background in the inherently colourless liquid. This is light playing a game with us again, for the eye interprets this image as a clear liquid and not a coloured one. The drink has made us a little bemused – quite a trick for a tipple.

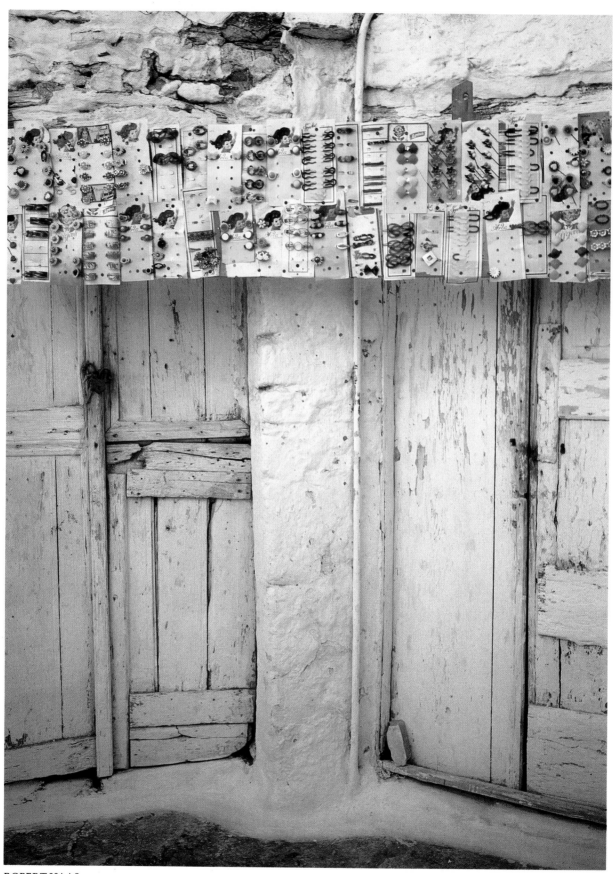

ROBERT HAAS

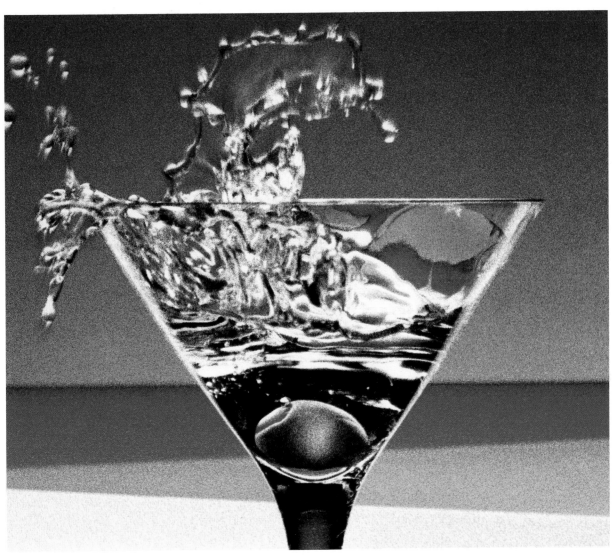

DAVID FAIRMAN

THE UNSTOPPABLE PICTURE
Irresistible looking

It needs some effort of the will, but if you look at any type of fixed spot for thirty seconds or so and concentrate on it, you will find that the world begins to fade and disappear, before your very eyes. Our central nervous system is essentially geared to recording change and we get bored to the level of blanking out if we do not experience it. The same rule applies to music, and a note played continuously over a period of time will eventually be heard no longer. Likewise on catching the first whiff of a flower's scent we experience it most particularly, but with repeated inhalations, this self-same flower will make less and less impact on the senses, until eventually one doesn't notice it any more. We may therefore count ourselves lucky that our natural vision does not function with the unreal obsessiveness of the camera, with its fixed and rather perspectival attitude. Our eyes are not merely a couple of camera obscuras set within the framework of the ball and socket, beaming from the lighthouse of our head, but rather two living sensory dancing partners that flick and flash irresistibly and in the manner of the continuous glimpse.

In our own personal 'picture' of the world we integrate over time as well as space, so that a feature seen becomes a part of memory in the very next instant. We are continually building up the image of our surroundings from a whole series of smooth and long-running snaps, and it is these that enable us to appreciate our surroundings to the full and ensure that we don't trip over our shoe-laces. We may shift our gaze from the television screen of signalled human beings to a more real world of directly transmitted people, their every gesture and move telling its own story, and we can receive the signals in the very finest sequence and resolution, and in all dimensions.

Because of the way we see the world, it should come as no surprise that a great deal of photography is acutely lifeless, and yet for someone to say that photographs are mostly lifeless does come as something of a surprise to many. The reason for this is that a photograph itself is regarded as a genuine article, an accurate reflection of reality. The truth of the matter is that we sense things in the 'round' and not just from a single viewpoint. However much the still photo seems to resemble the truth, by definition it only serves to imitate a split second of the greater spectrum in time and space. Hence the very thing that the photograph frequently lacks is a sense of life, and this is something that it all too often neither conveys nor makes any attempt to suggest. The camera itself is partially to blame for this, of course, although give it its due, it does its best.

There is little doubt that it takes the eye of an artist to see the matter in a more realistic context, and David Hockney, who paints as well as taking photographs, has satisfied some of his curiosities with regard to the 'problem' of photography. We live in a visual sphere, and by his own particular method Hockney has succeeded in presenting to us an unending picture which shimmers with light and colour, and one which possesses that vital ingredient so lacking in the normal photograph, that life-giving quality of time. Hockney, who has used photographs for years, for fun as well as for reference, found himself becoming acutely aware of the deadness of the photographic image.

People, who in the way we perceive them are generally full of life and energy, appeared to him to look dead in a photograph, 'stuffed', and rather like wax dummies. Indeed a particular photograph of his springs to mind in which a stuffed dog that happens to be in the picture really

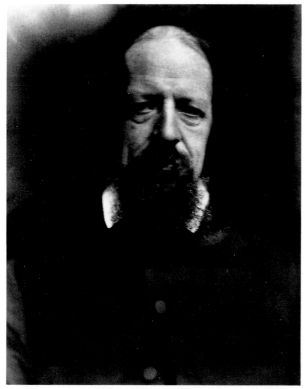

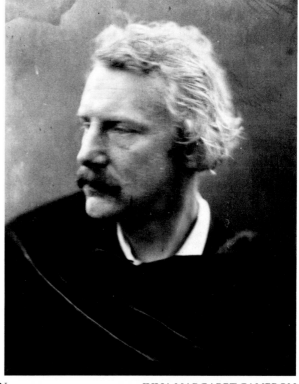

ALFRED LORD TENNYSON BY JULIA MARGARET CAMERON

JULIA MARGARET CAMERON

looks about as live as one would expect a dog to look in a photograph. There is no way of telling the difference between it and a living creature. People, Hockney feels, have that same stuffed look in most still photographs. According to Hockney, it is through the evacuation of time from the picture-making process, the elimination of 'sequence' in the making of the photograph, and the sheer instantaneousness of the camera's operation, that our likeness appears so static in the single photographic image.

Now of course shutter speeds on cameras have not always been so fast, and this fact alone enables us to make an interesting observation about levels of time, and the degree of life that is in an image. The renowned nineteenth-century photographer Julia Margaret Cameron appears to have bestowed upon her more notable sitters a sense of life and drama that was otherwise sadly lacking among the other practitioners of the art at that time.

There are two factors involved for our present purposes. One of these is the fact that she apparently placed her sitters slightly out of focus, immediately rendering them with a softer line,

and one more akin to the older masters of painting. This less plastic aspect of her more haunting personalities is already – because of its *suggestion* of movement – a sort of symbol of time. The other factor is time itself, the time it took to take the picture. Her sitters were forced to sit for several minutes at a time while the exposure was made, and one suspects that they groaned about it once in a while. It is clear, however, that in the course of this arduous action, somehow she and the camera have infused that magical quality of 'life' in the recorded and final image.

The very fact that in interpreting her photographs we acknowledge that her images have that sense of life is itself a confirmation of her success in her method and approach to the medium of photography. She uses a language that we can clearly and instinctively understand and appreciate. This level of time conveys something to us as we look at her portraits. There are inherent signals within these faces that trigger off a live response on our part. These are no wax dummies. After all, we perceive life through motion, our own movement as we go about, and

63

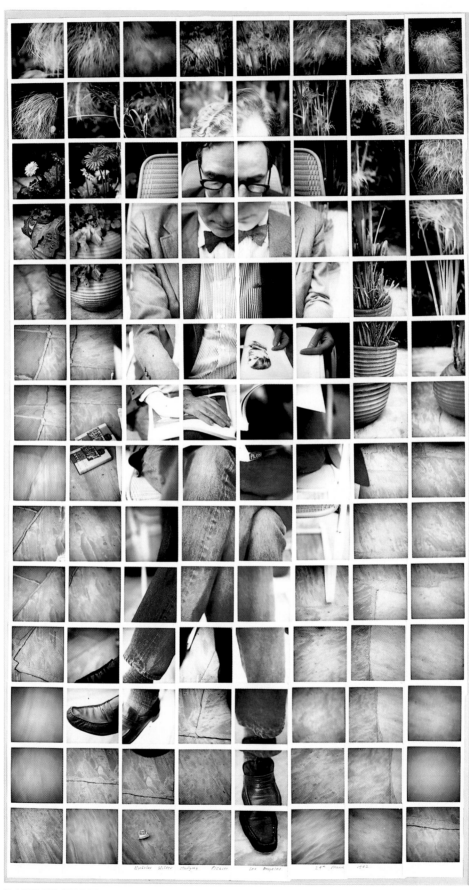

DAVID HOCKNEY

the movement of others. This movement varies in intensity. It can be very strong, as in a running athlete, or passive, as with someone sitting asleep in a chair. Either way, however, there is movement and time, and we can sense this in a photograph just as we do in a painting. We interpret time in a picture as life, it corresponds this way.

It is possible to illustrate the essentialness of time in a living picture by reference to a comparatively recent method of image making, that of holography. Putting aside the apparently three–dimensional qualities of the holographic image, it is important for present purposes to draw attention to the sheer speed of execution of the hologram. It is somehow appropriate that when Denis Gabor – the inventor of holography – was awarded the Nobel Prize, he had his portrait made by the holographic process (which by then was already reaching a level of sophistication brought about by the rapid development of laser technology). Gabor's features have thus been captured for posterity by a pulsed ruby laser at a relatively slow speed of approximately ten nanoseconds. (A nanosecond is one thousand millionth of a second.) There is not much that moves visibly in the world as we know it at that rate of exposure. The physical world is effectively brought to a standstill. There can be no better example of a creature being deprived of its natural environment within the context of time and being transformed into a stuffed dummy.

On returning to David Hockney's form of reference, the closest one is likely to get in a photograph to a hologram of the kind made of Gabor would be a photograph of a stuffed animal or wax dummy. A human being caught in this mode would only ever really be encountered like this if they were dead. The sheer speed of exposure of the pulsed ruby laser has brought all movement of blood through the veins, all the imperceptible flicker of life in the eyes, to a total halt. Because any idea of time has been completely removed from an image, we see it as having no life whatsoever.

It seems that David Hockney, who has observed nature in his own particular way, has hit upon a most effective means of conveying through the photographic image the sense of life and movement that otherwise only appears to exist in life itself or in the movies. Hockney's Polaroid collages consist of a jigsaw of individual Polaroid prints taken on an SX-70 model camera, and fitted together to his own personal choice and with a good measure of aesthetic judgement. In their total animation these composite images have produced a 'cartoonized' version of what we naturally see. We see arbitrarily and without apparent reason to some extent, although of course there is reason for us to do so. We dart from one feature to the next, and so does Hockney's camera, taking in as much interest from a plant in the corner of a room as a picture on the wall, as the shape of a person's cheek and the press of a hand on a book. Every aspect is approached closely, attention is paid to it with an individual snap, and then it is waited for, as it automatically develops in the daylight and by the Polaroid process.

Hockney's whole picture holds together in a remarkable way, although it is quite clear that his subject is distinctly fragmented. Further, there are more hands and arms and legs and feet than there should be, and yet for some reason it does not seem to matter. Now it has been suggested that the reason why we appear to integrate and live with these obviously broken squares when they are placed in such a combination is because we have been conditioned by Picasso. It therefore seems highly appropriate that Hockney's portrait of Nicholas Wilder should show the subject studying a book of Picasso's works. But who is conditioned by Picasso? Certainly one does not have to be conditioned by Picasso to interpret this picture as a wholly acceptable and complete work, although it is very clear that on quite close scrutiny the lines do not join.

Nicholas Wilder in this picture has three or four feet or more, and three or four hands, the hands coming from places where strictly speaking they shouldn't, and yet we do not seem to find this disjointed configuration too upsetting. People often wonder why Picasso's models have three eyes. The answer is very simple, one of the eyes has been *seen* twice. Hockney's form of presentation is in this sense a very realistic one, since we are in reality experiencing a whole series

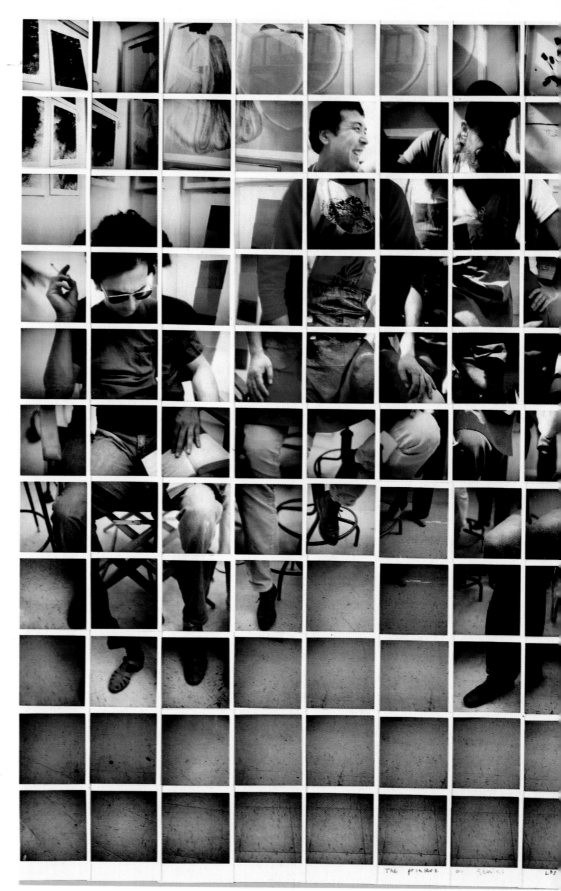

DAVID HOCKNEY

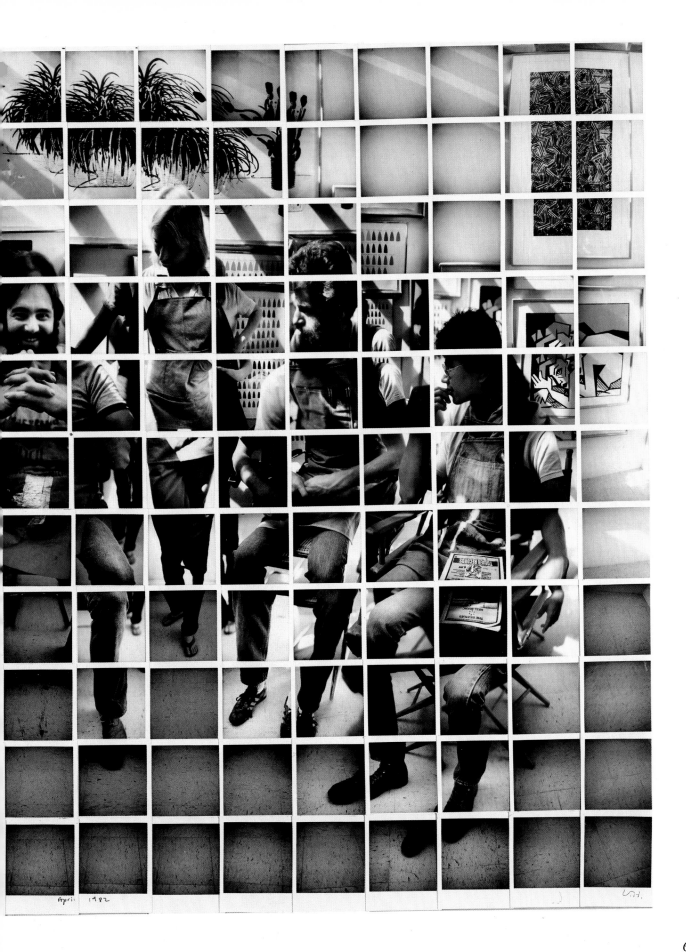

April 1982

of still lifes, one after the other and in sequence. Hockney himself draws some parallels in his work to cubism in painting, and he talks of how cubism is not something that is primarily concerned with abstraction, but rather with the visible world. He argues that Picasso was a cubist painter all his life, and that he never abandoned cubism. Basically Hockney is saying that cubism is an art form that seeks to represent the way that we actually experience the things around us, in a more *altogether* fashion, and from a variety of angles from moment to moment, and not from the single viewpoint that the camera adopts. The Polaroid collages therefore express interest from every sphere, and not just from one angle. These composite images find fascination in the slightest characteristic of gesture and stance, they are of themselves a study in decorum.

Moving on from cubism to cubes, it has been suggested that Hockney's Polaroid squares appear to have the effect of tesserae – the individual blocks of a mosaic – and it is true that they function in a similar way, and in an accumulative manner. Now the very best mosaics, some of which can be seen at San Vitale in Ravenna, show the masterful Byzantine technique of placing the individual glittering stones in such a way and at varying angles so as to allow light to catch them differently as we move about before the complete work. Our physical movement in front of the mosaic creates a change in our perception of its total structure. We effectively cause it to alter because of our own motion through space. We experience real live things in the same way, of course, and every subject of our eye alters its shape and colour as we move about in relation to it. David Hockney *moves* in order to take his pictures too, actually walking into the picture's own airspace. During the making of a portrait of the poet Stephen Spender, and while Hockney was himself engrossed in photographing a piece of floor in the corner of the room, Spender had good cause to remark, 'Are you still taking *my* picture, David?'

The important point is that the closeness of the camera to the thing it is photographing makes it possible for the Polaroid camera and its fixed lens to give quite fine resolution to the structural details of that object or person. Also, colour

HOLOGRAM OF DENIS GABOR BY D. LESSING

appears to 'leap out' of the atmosphere of these works of Hockney, and this is brought about by his closeness to the specific scene of his attraction – whatever that feature happens to consist of. It should be said that the proximity of the camera to a person's face seems to influence its mood, resulting in a higher level of human involvement in the complete picture, where by comparison a single photograph featuring a number of people together would appear more dispassionate.

A normal photograph makes an average judgement about light levels, so that a photograph when properly exposed will feature light and dark areas, all of which will contain features of interest, but not all of which will be visible in the finished picture, since they may have been inappropriately over- or under-exposed. Certain things become 'absorbed' by the lightness or darkness of things, and hence they disappear from our view in a rather unfair way. Everyone knows that there are compromises to be made in the creation of a single photograph taken from a fixed viewpoint. Likewise the inherent colour of a thing at a distance from the ordinary camera will not emerge in the way that it will if you are right on top of that self-same thing, for instance. It therefore appears as if we are dealing with some form of atmospheric perspective, although this is not really the case, since the distances involved are not sufficiently great for that to have an effect. Rather, the effect here in Hockney's snaps is brought about by a quality of the Polaroid camera's exposure judgement of objects at close quarters. Nicholas Wilder's trousers appear with their full blue jean texture, as does the lovely little still-life of flowers in a pot, with bright red and yellow blooms.

On the question of perspective, it is certainly true that Hockney has found his own in these multifarious images with their separate and varying viewpoints. It seems that Hockney the photographer has departed somewhat from the more generally accepted Renaissance tradition of presenting a picture with an apparent and limitless depth, and one within the framework of which everything fits and has its place in the order of space. By some contrast, the Gothic convention of presenting separate and individual

HOLOGRAM BY BILL MOLTENI

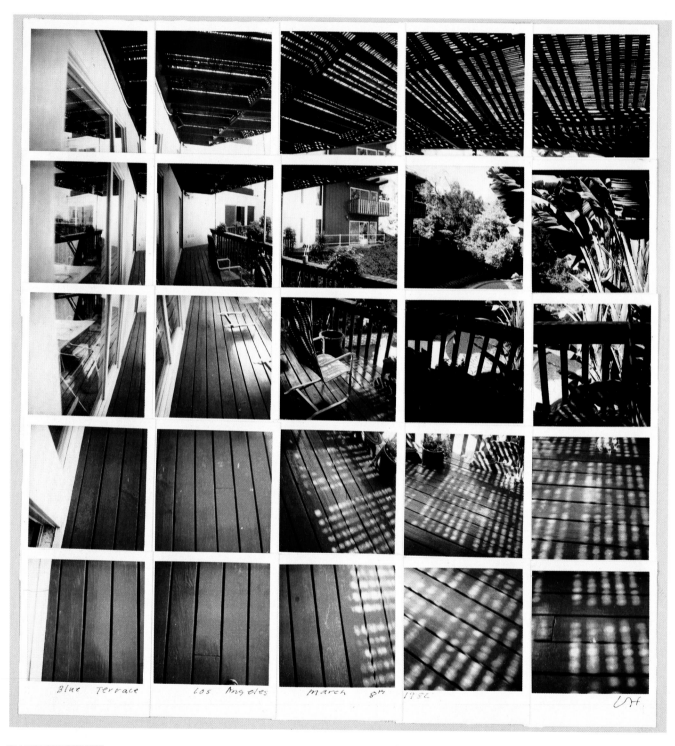

DAVID HOCKNEY

points of our universe across an otherwise flat plane seems to run closer to Hockney's sequential way of looking at the world. One is reminded of the famous tapestry that hangs in the Cluny Museum in Paris, belonging to the series known as 'The Lady with the Unicorn', where nature is truly seen to do its thing, in superabundance, and in all directions.

This way of seeing can be compared to a mother or a teacher saying to a child, 'Draw me a picture of all the things that you saw today'. The child would then draw, in bright bold colours and with perfect logic, a bold 'Mummy' figure, a blue tree, a green sky, maybe a red house, and a yellow pussycat, and all floating in a heavenly ether. Now there is an apparent contradiction here, as well as a cross-over point, an overlap of sensibility. On the one hand we do see things within the framework of Florentine perspective. The visible world could be said to work like that.

Yet on the other hand we perceive and take in things just as a child, and we understand physical objects almost like emblems, so that they appear to us to become a type of instant sign language of immediately recognizable shapes and forms.

In Hockney's photo-tapestry, the association of a piece of chin with a bow-tie is something that we have no problem in coping with – the chin/tie combination has itself already become a type of heraldic symbol. Similarly the feet, and the spectacles on the face have become rather like part of a coat of arms, belonging to some Worshipful Company of Spectacle Makers, some Honourable Guild of Shoe-makers. In the same way we experience no problem in resolving the matter of two left hands at the page of a book, since this is what a hand does for *its* trade with paper, it flicks a page and then it flicks it again, and we see it do so as a matter of course.

CLUNY TAPESTRY

Hockney first started working with Polaroid prints in this way by a kind of accident. Disliking the effect that wide angle lenses have on their subject matter, Hockney made for his reference instead what he calls 'joiners', individual snaps which he then spliced together to form the total subject. Already he began to feel with these very few ordinary photographic prints – one of them for instance of a single figure made up of five snaps – that the total image now had a greater presence about it than a single photograph would have. Finding himself at some later date with a batch of Polaroid film that he had left over from the documentation of some of his other work, he began to photograph his house in Los Angeles, step by step, as if inviting the viewer to take a tour through the place with him. One could move from room to room and right out on to the terrace and see the swimming pool.

Hockney found at an early stage that the Polaroid squares could not be arbitrarily placed, since otherwise the relationship between them would become confused, and the composition would fall apart. He began to re-shoot those frames that did not function effectively in relation to their neighbours. In his picture making now, Hockney made no attempt to match the prints perfectly in the way that he had done with his joiners. The collage here, of his quite early 'Blue Terrace', therefore has its own very distinctive dancing perspective. This is fanciful stuff, and it is clear that Hockney had begun to realize the medium's potential at this stage. He relates his work in some respects also to Chinese scroll painting, where the viewer is invited not merely to look through a window of the picture, but rather to step through a door and thereby enter the painting's narrative sequence. A journey through Hockney's house is of course another kind of 'story', and quite a colourful and lively piece of journalism at that. There is no paralysed cyclops at work here.

Almost inevitably the Polaroid collages became larger and more complicated, until he reached a stage where a group portrait of the printers at Gemini took him more than three hours to complete. It almost came as a surprise to him that one could be half way through the making of the picture, and still it was possible to

alter it at will. Consisting of a total of 187 squares, it is his largest work, and in its absolute animation takes us on a journey of a different kind. Here in this array we can almost see layered time itself.

Hockney quickly realized in his image-making that one cannot perceive space without time, that it takes time to perceive space, and that the reason why a single photograph is essentially static is because there is not enough time within it to perceive the space that it is depicting. Effectively it is the same time in every part of the picture, whereas in a painting we may sense the motion of the hand over time. On this point, Hockney says that one can sense when a drawing or a painting has been made through photographs, since one can sense when a picture is not felt through space. After all, our bodies and eyes move all the time, and over time, so there are many points of focus and many moments, and these are continually building up our natural picture.

To Hockney the camera truly is an extraordinary drawing tool, and in this abundant group portrait we can see how he has followed the lines of the people featured. A normal photograph of seven people in a single frame would never have had such co-ordination. In its patent insistence that everyone pay attention at exactly the same time, and its inherent impatience that everyone should do precisely that and without deviation, it misses the odd person, and gets them out-of-synch. The normal photograph rather reminds us of the bossy wedding photographer who attempts to get everyone to do what he wants, but rarely succeeds because everyone wants to have fun in other directions. Hockney's more patient and living camera has allowed people to do what they want, and in their own time.

These figures are observed with an intimacy and an attention to detail that makes the act of seeing an intensely enjoyable one. We are asked to look that much harder, to participate in this picture, to be inquisitive with him about the nature of things. Drawing with a camera is undoubtedly very different from painting with a brush, although these images have already led Hockney on to more discoveries in his painting.

The development seems logical, from one discipline to the next. But then of course painting itself is a science, as well as a hobby, and so we come back to the interminable question – what came first, the Hockney or the Art?

It is only reasonable, in order to counter criticisms of the white grid in Hockney's collages, that some proof should be offered that the world does appear like this in reality. We have conclusive evidence of this in Chris Bonington's interior of an igloo, where the world is truly seen to consist of composite blocks, each and every one placed critically, with a high level of art and a practical sense of composition. Bonington, who is also a traveller in time and space, captured this view of the real world with a fish-eye lens. The camera was placed flat in the middle of the igloo and the 180 degree angle emphasizes the spiral build of the 9 inch thick snow blocks. Here in this icy panoply we may surely see that we live in a visual sphere, and that white lines rule our lives.

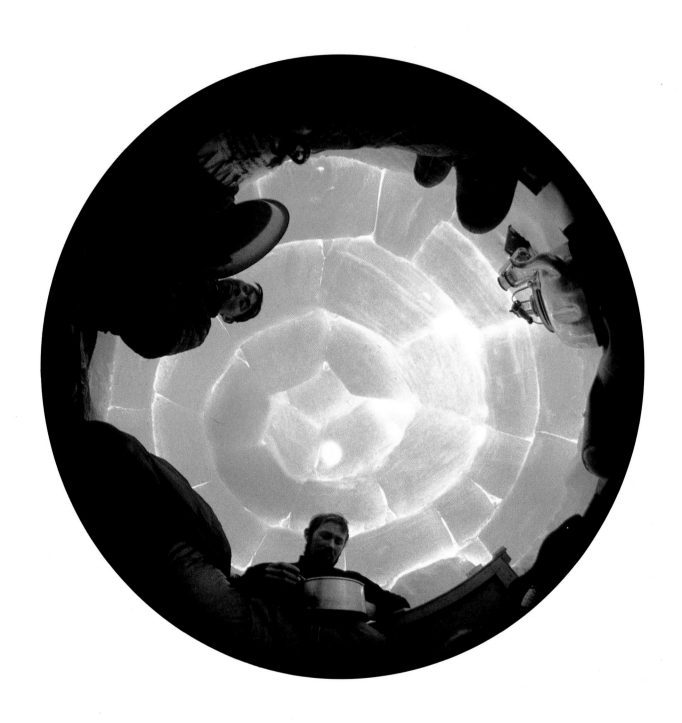

CHRIS BONINGTON

THE SERIOUS EFFECT
Pictures in and out of perspective

W. Eugene Smith's photograph of a mother and child still strikes a chord in all of us. This Japanese Madonna looks upon her monstrously malformed daughter, the victim of Minamata Disease and the result of poisoning through industrial mercury effluent, with an awesome love, and one that fills us with our own shame. There is little doubt that Smith reached a peak in the making of his photo-essay when he caught this piece of humanity in the soft gloaming of a stricken family's bath-house.

Eugene Smith's story, for this is after all a masterpiece of photo-journalism, was the disaster of Minamata, the callousness of mass industry and the destroyed lives of the small community that bore its most direct brunt. Here is a clear example of where, above and beyond the desire to make pleasing and beautiful pictures, the photographer has also a direct and important responsibility. That responsibility is of itself to respond, with heart and with feeling. There is ultimately no short cut to the making of such a sublime image, other than for us to be the open receiver of such messages that the outside world has to offer. More often than not, a transcending picture is the one that appears from the most ordinary of circumstances. Somehow a simple scene may touch us, but only if we are there to allow it to do so. In this respect, the camera is not merely an extension of our eye, in the way that the great Henri Cartier-Bresson conceived it, but an extension of our greater sensibility. We can thus truly photograph what we feel.

Leica photography is of course all about the split-second capturing of the vital moment, and photographers have spoken often of how snugly the older models of Leica fit in the palm of the hand, how comfortably they fit against the face, and how well adapted the camera is to human shape and handling. Now it is true that one can get used to anything, but there is little doubt that

once well accustomed to the spontaneous and immediate use of some of the classic older models of Leica, the photographer is unlikely to want to break the habit.

Eugene Smith's picture has about as high a level of natural response as one could hope for in a photograph. This we can only regard as his most personal achievement, the result of a caring eye. The photograph was simply taken using the available light from some small windows placed high in the room, and the gentlest hint of flash bounced from the ceiling.

The absolute intensity of black and white in, say, Eugene Smith's photograph of a mother and child is one thing, but the absolute intensity of colour is quite another. Irving Penn's poppy, like some heavenly bombshell of luscious rich ruby crêpe, a party dress all-a-ruffle and freshly on show, explodes before us in the dazzle of Penn's bright lights. It is clear that not all of Penn's work is undertaken in the mysteriousness of his daylight. The flower's every dew-drop picks out a studio light like a jewel and a sequin. The rest of nature has been thrown to the wind as we contemplate poppy and poppy alone in her splendid isolation. It should be said that Penn's flowers are not always presented to us so perfectly, and this one is very special. His blooms often show their blemishes and signs of imminent decay. These are qualities that Penn particularly favours from time to time in his photographs, since such blemishes show the natural order of things and signify a gradual but sure return to the soil.

Nature closely observed will of course always serve as a subject form for the inquisitive photographer, and whether one chooses to isolate nature's inventions or capture its creations in the outside world is a matter of personal taste. Either way, the photography of nature is an endless

W. EUGENE SMITH

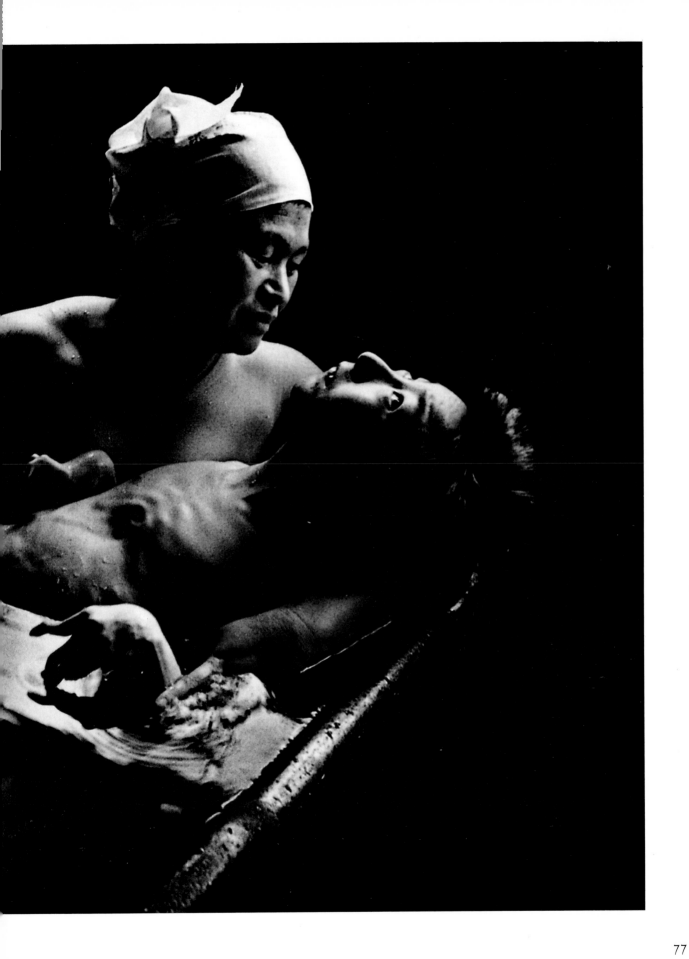

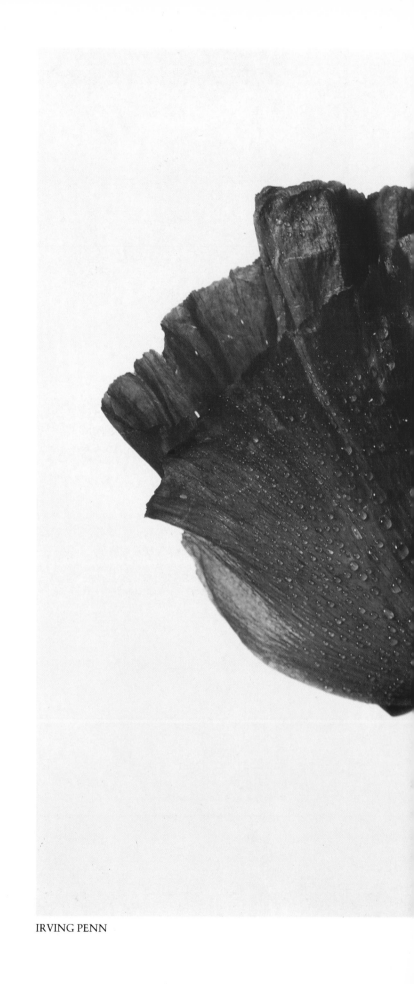

IRVING PENN

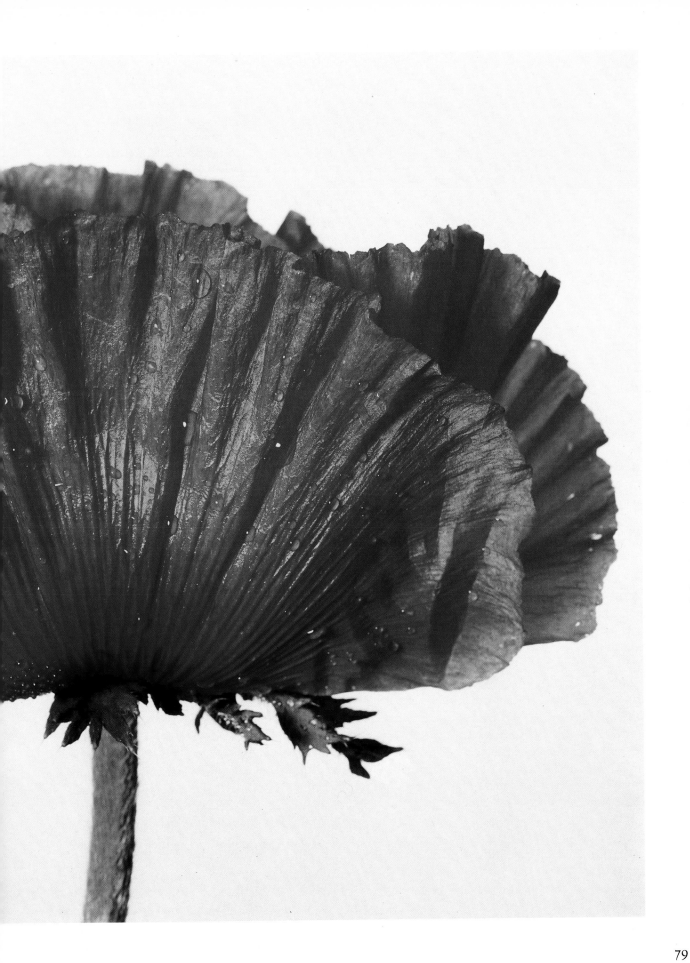

search and a limitless encounter, and at no stage can the photographer claim to have seen it all before. Hence, and in the same way that Leonardo Da Vinci depicted flowers and plants in his sketches as if seen for the first time ever, we may make this astonishing discovery with Irving Penn as to the true character of this previously unexplored poppy. Above all, we do well to remain surprised by the natural world, and for our senses never to be dulled to its inspiration, and to the finest detail.

A human invention, and a most perfectly crafted and finely honed piece of machinery tuned to a razor's edge, is Richard Cooke's Tornado aircraft. This devilish plane bursts from a blameless blue sky without apology. Cooke has caught the creature in a most characteristic wide angle perspective. The dynamics of his lens are highly suited to the subject and illustrate dramatically the nature and mood of this sleek interceptor, its immense power like one taut muscle in mid-flight. Cooke shot the picture with a certain fearlessness and a 20mm lens from approximately twelve feet away, using his aircraft's weapon system in the normal fashion to operate the shutter release. In more conventional use, a button would have dropped a bomb or fired a gun rather than taken a picture.

Cooke says of the plane, 'In its way it is a work of art, it is an uncompromising machine, a pure piece of workmanship. In the picture it looks pure, and equally uncompromising.' The camera was situated on the outside of the leading aircraft, and they were cruising at just over 500 mph when the picture was taken. Cooke, who has a background in fine art, invariably draws his plan of action on paper before he takes any pictures. He has a bundle of sketches of the as yet untaken picture. In Cooke's drawings, all practical considerations as to the viability of actually producing a photographic image in accordance with his scheme are temporarily put aside. The concept at this stage takes pride of place. It is only later, once his idea has been developed, that he starts to look for the most suitable equipment for the job. If that equipment does not exist – which is frequently the case according to Cooke – then he invents it, and for the specific purpose of the picture.

On the whole, Cooke – who regards photography as a most effective means of illustration – tackles each and every job he has as an idependent enterprise. He has flown in a wide variety of aircraft, and so it is inevitable that his approach to a problem should be a fresh one on each occasion. This is why he regards the attitude to the job in hand as being of the greatest importance. After all, conceptualizing is one thing, whereas practical application of an idea, and always in a unique context, is quite another.

Cooke naturally works closely with fighter pilots and their engineers. His main technical adviser and engineer is Alan Voyle and their relationship is essential to Cooke's photography of aircraft. He confesses that a less than perfect picture is usually the result of a break in communication somewhere between the parties involved. There are immense problems in building cameras on to the outsides of aircraft, and the difficulties caused by extremes of temperature and wind buffeting, not to mention aircraft vibration, are legion. It comes as something of a surprise to discover that Cooke's shutter speeds are often markedly slow at a 30th of a second or so. His methods of coping with the stresses imposed on cameras when pushed to such extremes are techniques that make use of a good measure of high technology, sheer initiative and practical day-to-day experience. Such things – understandably – he does not speak too freely about, other than to say that what he does with a Nikon is a great deal more stressful than taking a Hasselblad to the Moon.

Leonard Freed's Harlem kids seem to find their ecstasy in the spray of an open hydrant on a hot summer's day. Freed, it is clear, is a Leica photographer and his response to such a moment is as immediate as the subject itself. It has to be said that not all of his images are as joyous. Freed is a finely tuned operator in more ways than one, for purposes of survival as well as for aesthetic reasons. Having worked in New York's Ninth Precinct, one that had a record for more policemen being killed in the line of duty than any other, he has had his life on the line on a number of occasions. He makes it clear that in such tight situations, as for example a police raid on a 'shooting gallery' in which drug addicts are

caught in the act, one has to react instinctively as a photographer, whilst remaining completely aware of what one is doing, and not getting in the way too much, just in case bullets start to fly.

Discretion has often proved to be the better part of valour with Freed, who has frequently been mistaken by hardened criminals for a policeman himself, and by the police themselves as someone from 'upstairs' doing a check-up. Sometimes one can't win. He has, however, found his own way of coming to terms with the potential violence that exists around every corner of a teeming city. He makes a useful comparison between street awareness in the great metropolis and the seemingly 'safe' life that one lives in the country. After all, in areas of countryside where rattlesnakes are prevalent one cultivates a third sense in order to cope with a known danger. There, for instance, you instinctively scan the surface of the ground before sitting down for a picnic. Freed says, 'You can travel all over the world and go to all sorts of places, and basically, if you're careful and don't go around with the idea that you're infallible, then you'll mange OK. I never carry a gun around with me, for instance, or any kind of weapon that makes me feel that I'm going to "protect" myself. I only carry the camera.'

Even so, and whilst Freed makes it clear that he regards the Leica as the most 'intellectual' camera that one can use, and lightning fast in its operation, he nevertheless adds that the Leica is also built very sturdily and with some weight. It can hence always be used to hit someone, as a final resort. 'It won't fall apart,' he says. 'If you hit someone with some of these Japanese cameras, they'd probably shatter and concertina – that wouldn't happen with a Leica.'

How does such an instant picture as the fire hydrant come about? Freed says that as far as composition is concerned, he works in such an 'immediate' situation instinctively, and often without knowing what's going to emerge at the end. He thinks of himself as a hunter sometimes – shooting with the camera. 'You move about and it's like a dance, you move up and you move down, and you try to involve yourself with the people, but then you also keep your distance. If you start to talk too much, then you can't photograph, if you only photograph, then you don't get to know what the people are like. You have a limited time to work, and you have to sense when it's time to leave.'

Freed also tries to work out how much time he will have to shoot pictures in a given situation, and how fast he can move into a scene, should that prove necessary. It could be said in this respect that he tends to act as the mood grabs him from time to time. Indeed he sometimes thinks of himself as rather like a child, jumping around and playing games, and certainly not regarding everything with such ultimate seriousness.

Leonard Freed has said that in a war the photographer goes to the place where the shells are going off, where the action is. It is therefore quite in keeping with this that a certain area of South London undergoing a good measure of civil unrest should have attracted Homer Sykes – a master of photo-reportage – as well as me to its battleground. The National Front were marching, and there were plenty who were determined that they should not be given the space or the time of day to do so. I don't know what was going through Sykes's mind on his way to this vast demonstration, but I do remember what I felt as I got on the bus going to Lewisham. I was determined that nobody was going to grab my Leica and I was set on getting a good picture. I suspect that Sykes must have felt something similar. I can still remember paying the bus fair with a distinctly sweaty hand, and a strange dream-like feeling in the head that I was paying to go to battle.

As for Sykes, he had spent part of that day photographing things at street level and certain individual confrontations between people who were hitting each other for one reason or another. Soon, however, he began to feel that it was time to get the more overall shot of the day – the shot that said it all, if that was possible. In order to get some height, and without raising himself to too high a level that would only result in a hoard of tops of heads, he positioned himself none too securely on the top of a bollard on a traffic island in the middle of the street. From the vantage point of this precarious obelisk Sykes

encountered a looming and sinister panorama, the figures of police guardians and demonstrators emerging from a miasma, a thick pea-soup of smoke bombs.

The Flemish painter Hieronymus Bosch would have thrilled to this scene, for this must surely be the apocalypse – the triumphal procession for the Beast himself. Sykes photographed this scene on a Nikon with a 200mm lens, which has clearly selected its point of interest. The defiant fist in the foreground acts as a final confirmation, and nails the picture firmly down. Sykes makes it clear that a news picture of this type has to be readily identifiable as well as dramatic. It is therefore useful to have banners of some description in the photograph in order to 'place' the situation. Sykes stresses the importance of moving around during a demonstration of this kind, since there is a noticeable tendency on the part of some photographers to rivet themselves to a particular vantage point and then to use that position alone from which to photograph. Whilst it is true that a good position may produce a good picture, nevertheless it does not produce a good series of pictures, the making of which should be the endeavour of the ambitious photojournalist if he is to get his material published extensively. Setting up a scheme whereby you keep a careful track of those aspects of an event that you have covered and those that you have still to tackle is a wise course, and this can make for variety in your story.

In the meantime, I myself was experiencing very little variety where I was, stuck at the bottom of a steep slope down which the police had just pushed the crowd. With corrugated fencing on either side and two rows of arm-linked police – like a couple of firmly entwined ropes – there was no budging any of us and everything felt completely intractable. After some people had thrown bricks and bottles, red powder paint and a few smoke bombs, the police tactic was to divide and rule. This they effectively did, but the small and isolated crowd got a little frustrated in parts, and while I clutched the camera a few lively individuals decided, with almighty bounds and leaps, to break through a piece of metal fencing. They almost succeeded. No sooner had these

RICHARD COOKE

82

three bodies launched themselves with reverberating thunderclaps against the corrugated iron structure than three or more policemen shot up from behind like Jack-in-the-boxes on request. I couldn't believe it, and they stayed there while I shot off two frames. But the best photograph was the one with the piece of pavement. Where Homer Sykes's picture of that day showed people emerging from the depths of some sea, and quite literally coming out of the atmosphere, my shot couldn't have been flatter, and even then in amidst the activity, this seemed like some weird drawing that someone had suddenly stuck in front of me. It only goes to show that we both saw things on that rather fateful day, and that we interpreted them in our own distinctive fashion.

Sudden surprises can come to us all, whether they leap up as Jack-in-the-boxes, or prance out like marionettes. Chris Smith's competitors in a biathlon step their spidery way across the whiteness of Lake Placid, resembling so many oriental shadow puppets. These stalking, shooting men were not caught by entire chance. Smith had observed the effect of shadowed light on the snow from surrounding trees and realized what effect he could achieve. He asked the group to ski-walk before his camera, only to discover that a problem of co-ordination occurred and that if he tried to feature more than four figures at a time, then the design became upset by that odd person, who was always out of step. If this happened, the symmetry of the image would be lost. As it is, Smith's picture is a study in human motion that immediately reminds us of the exercise of the photographer Eadweard Muybridge. On the other hand, we have to remember that each and every figure in Smith's photograph is an individual personality, and that this is not a repeat and developmental performance by one person. The fellow would probably have got pretty bored, and rather chilly with Muybridge on the job.

To Chris Smith, the fact that the bulk of his work is undertaken in the field of sport is almost incidental. But Smith is aware, above all else, that a picture for reproduction in *The Sunday Times* may not hang in the balance. It must have unquestionable impact if it is to leap off the printed page. Simple graphic images, with not too much gradation, work particularly well in this respect, says Smith, and it follows that an image of this kind, and one with little complication, makes a step in the right direction. This British Army team can stride happily across any front page.

Terry O'Neill's powerful, anonymous and utterly silent portrait of Harold Robbins shows a particular use of reflection. Reflections in glasses are at the best of times a matter of interest to the photographer, says O'Neill. But then these spectacles reflect no personality, only the calm and settled waters of success and great wealth, the edge of a yacht and Cannes Harbour. The dome head of Robbins seems merely to be a continuation of this motionless and sun-drenched sea, as if all have blended together as one, and each become a party to the other. The chubby chin seems to speak for itself, although the mouth does not, while his fat cigar is fixed firmly and absolutely within it. This ominous and faintly surreal portrait illustrates well how an apparently plain presentation of a human face can convey some matter above and beyond the mere visage.

Although O'Neill prefers not to adopt this style of portrait photography very often, he stresses that there is a temptation to approach a sitter in such a symbolic way. The method works most effectively for him from time to time when he wants to show someone in a certain light, and in this case and in his own words, to allow the subject to epitomize 'the silence of wealth'. Having photographed a great number of stars, O'Neill is very conscious of people's susceptibility to the camera and the whole procedure of photography. He does not deny that the camera is capable of stealing a part of the soul of a person, that the camera is in its way a lethal weapon that has to be managed responsibly and with great care. At another level, Harold Robbins does not appear to have given much away in this portrait.

Nothing is ultimately secure, and this fact is brought home to us by Brian Griffin's remarkable night shot of a street with a lamp-post and a gate. Griffin explains that he was looking for a 'non-subject matter situation'. In other words, the circumstances of the picture were to be virtually

LEONARD FREED

non-existent. Who would ever have conceived that such a bare stretch of street below Heathrow Airport's runway could have made such a masterful image? At night-time, of course, each and every feature of Griffin's view would under normal circumstances have constituted unavailable information – or pretty nearly. However, subject to Griffin's twenty second exposure and his use of additional flash, the street and the bracken on the side of the pavement are picked out in detail, as are all the other features of the composition.

Now over some period of time, and having lived in the flight path of an airport for a while as well, Griffin found that the sensation and experience of planes coming over with their landing lights on caused him to dwell. After a while each and every aircraft would almost be discernible through its characteristic landing lights, and each individual cipher would imprint itself on his senses. The potential for aircraft to draw distinctive lines in a picture began to take shape in his mind and it was with the incentive of a specific project on the theme of 'London at night' that he eventually decided to use the light-drawing medium of aircraft in the night sky.

The goal Griffin had set himself involved rather unsociable hours, and his considerable experimentation with Polaroid film allowed him to judge a given effect and to exercise a degree of control over the desired result. The aim of Griffin's photograph was not merely to show a Jumbo jet or a turbo prop about to settle down on the tarmac, but rather to document the very moment of that most silent of happenings, and the few seconds before the missiles home in on us. In short, this is the picture just before the end. In this little piece of nowhere they shoot past us briefly, with their own electronic sense of aim and purpose.

Griffin's picture, taken on a Hasselblad firmly mounted on a tripod, and critically framed to his choosing, succeeds in creating the ambience of the nuclear scenario, and the enigmatic atmosphere of the final moment, rather than presenting us with more obvious forms of reference such as that of a mushroom cloud and a massive scream. Griffin has

attempted along this short stretch of bare road to create a feeling of impending doom. His long exposure has captured a beaming flight path, and the whisp of a passing scooter. The light from the lamp-post has recorded its own measure of detail, and his flash has among other features created a magical spark on the reflective lock of the gate. Thus the picture is effectively a compilation of recorded light forms, together combining to make an abstract composition, and one with sufficient symbolism.

Whilst it appears that there is an almost conclusive inevitability about some things, nevertheless for certain people there is evidently a chance still to get out in time, albeit at the very last moment. It was while the photographer Robin Adshead was momentarily and infuriatingly distracted by his magazine editor to look in the wrong direction that a Harrier Jump Jet – practising for an air display at Episkopi in Cyprus – began to make some interesting moves. It was September 1973, and this was to be a demonstration of fire power for the military big wigs. The Harrier was just entering into service at the time, and the aircraft was to display a manoeuvre whereby it could be seen to hover in free air, then point its nose up at 45%, lift its landing gear, and finally blast off, changing smoothly from a free-air hover into forward flight. 'It's quite a manoeuvre,' says Adshead – who knows what he's talking about, having flown helicopters extensively in the services himself.

Adshead therefore duly trained his camera at the plane in question in order to record the sequence of its flight and its mode of transition. But nothing was to be so simple. Adshead's editor – who he says had his good points, though timing wasn't one of them – suddenly exclaimed during a phase of critical focusing, 'Here comes his mate, get him!' His 'mate', says Adshead, came shooting over a rock all of a sudden, only twenty feet up in the air. Adshead swung his Leicaflex and its Nikon 500mm Catadioptric mirror lens round and took a singularly indifferent picture of the plane's tail pipe as it disappeared into the distance. Having firmly decided to take no further note of his editor's instincts, he re-focused on the Harrier that he'd had in his sights – which by this time had moved out of its hover. Adshead saw in

ROBERT HAAS

HOMER SYKES

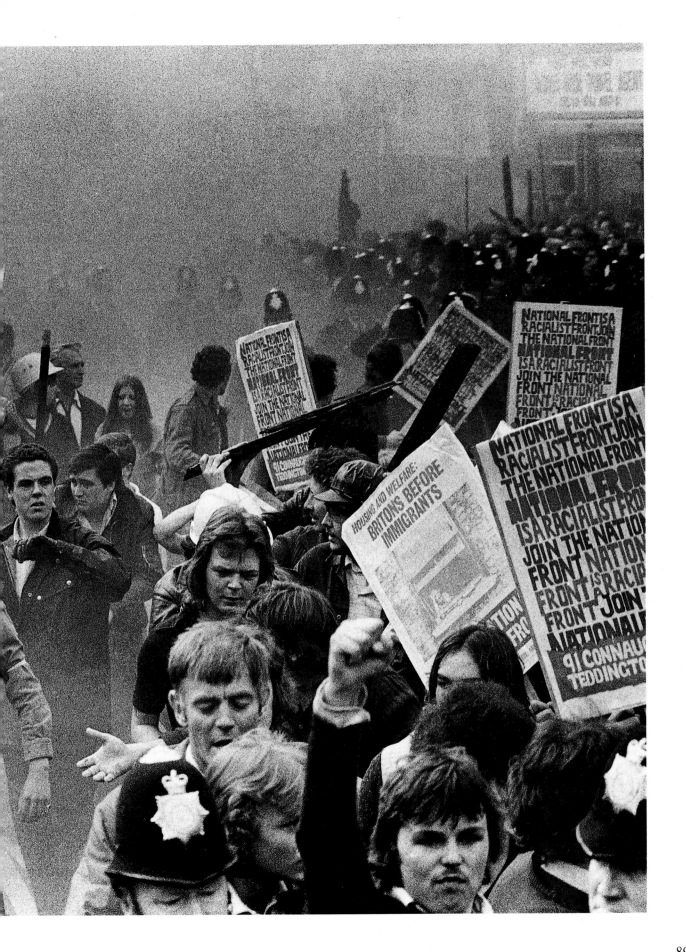

CHRIS SMITH

his viewfinder the jet blast off, but instead of it moving off smoothly, he saw that the nose began to drop and flutter. His helicopter pilot's instincts told him that the plane had come off its 'ground cushion' – its column of solid air – and had lost its balance. The pilot was no longer in control.

Whatever was happening here, and it could after all have been a highly accomplished piece of display flying, Adshead instinctively pushed the shutter of his camera, and just as somebody or something came shooting out of what he thought was the back seat of the aircraft. 'Boy, this demonstration's got everything,' Adshead recalls thinking, 'they're firing dummies now out of the cockpit.' But as he continued taking pictures, it dawned on him that this Harrier was a single-seater aircraft. By this time, he recalls, the plane had gone into an uncontrollable nose-dive, and within two seconds it had exploded on impact with the ground and burst into smithereens.

The ejected pilot, who was of course very much for real, found himself automatically floating down by parachute and into his own fireball of wreckage. A physical training instructor who had been painting white lines on the football pitch where the Harrier disintegrated had found himself suddenly showered in pieces of burning plane and yet managed to summon the wits and the courage to pull the pilot out of the wreckage. The pilot himself, Flight Lieutenant Geoff Hulley, managed to escape death with a broken left ankle.

For Robin Adshead, however, the fun was only just about to begin. He was immediately appointed to the task of photographing the wreckage of the crashed plane as it lay, and by an Air Vice Marshall. This he agreed to do. Meanwhile and in the process of this documentary photography for the board of enquiry, there was the sudden thunder of boots as a corporal in the RAF Police appeared on the scene and demanded that either the film should be destroyed, or possibly the photographer. Adshead says, 'It really got rather heavy, and it was touch and go as to whether this bloke was going to have my film or not'. Eventually, however, the corporal was called off and the photography was allowed to continue. The RAF then insisted that all the film be processed through their own laboratories, which in turn made a total mess of the bulk of the processing through bad chemicals. By the grace of God, says Adshead, the frames of film that emerged intact were the ones he had taken of the ejecting pilot. All those other pictures of burning wreckage were ruined.

This once in a million picture of a pilot escaping with life and limb in an ejector seat, and from a stricken aircraft, has actually saved lives. It has already proved to be a revealing image for air safety. A fault in the seat harness of the ejector seat could now be observed – a fault that allowed the pilot's head to drop too far forward on exit. Modifications have since been made that restrain such free movement of the head. Robin Adshead did not use a motordrive for the picture, and neither Nikon nor Leica have expressed interest in buying it from him.

TERRY O'NEILL

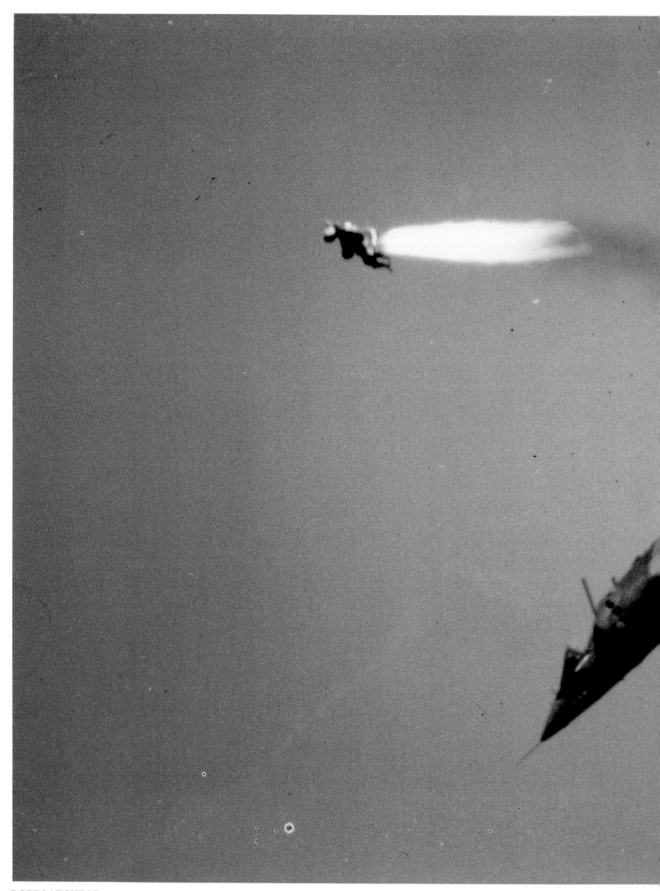

ROBIN ADSHEAD

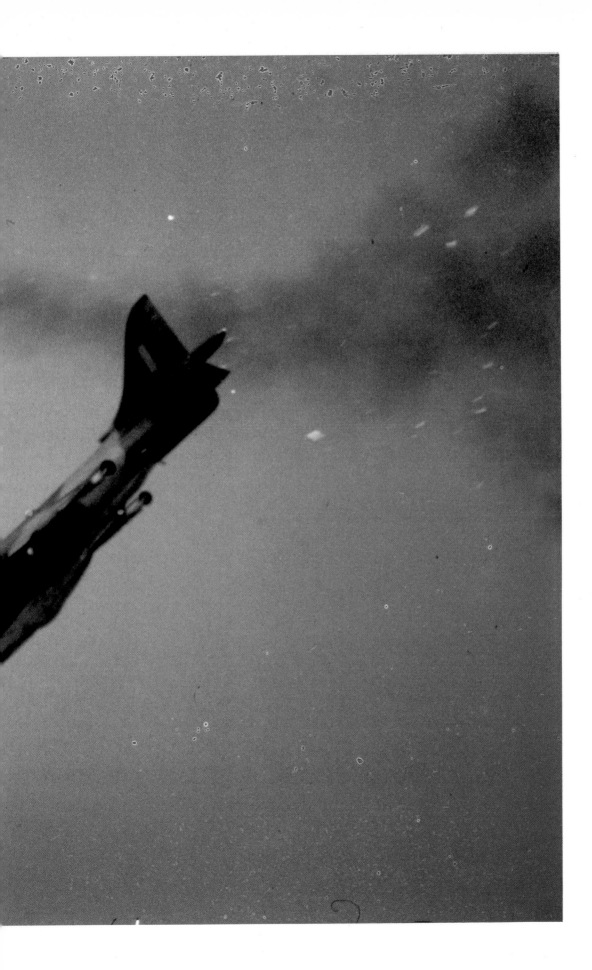

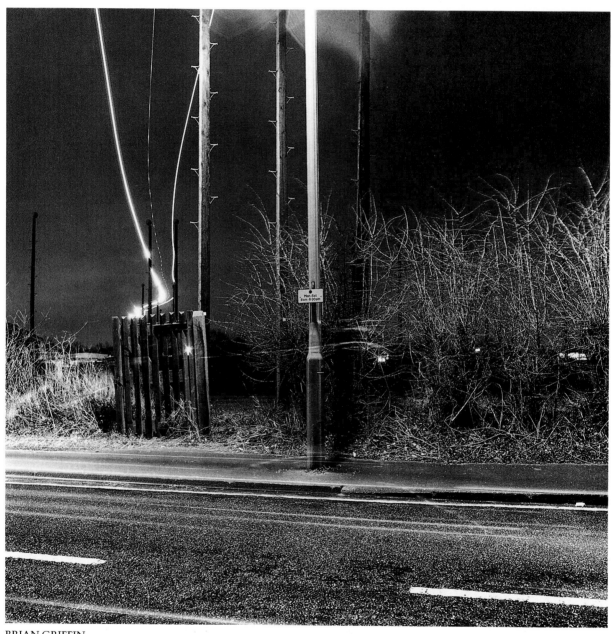

BRIAN GRIFFIN

THE DEVOTIONAL EFFECT
Alter pieces and alter egos

Among our more private passions, our gods and our heroes take many shapes and forms. Through our own particular creed, the world takes its shape, a kind of everlasting picture show of our insides. It is just as well that we look through a glass dimly – rather like the camera – since too much reality at once would undoubtedly be overpowering. If we take things by a fairly safe and step-by-step route we can still observe and come to terms with our various selves, and possibly without our being overcome totally by those alter egos.

It seems that Bob Carlos Clarke knows a little about our other person, since he does cause the viewer of his sublime and mystical image to tune into some secret desire. This at once intriguing and dreamily inviting twosome – a ruling and anonymous mistress in a black dress and gloves, a coolly naked and submissive blonde in her absolute possession – seem to beckon us somehow.

For Carlos Clarke, images do not need to have much of a prearranged and predetermined aspect to them, and a picture is often best left to take its natural course, and instinctively so. This is a particularly economical image of his and it relies on very few props in order to achieve its purpose. The idea of featuring two women together in such a mode is, says Carlos Clarke, an age-old fantasy. A difficulty, however, arises in the making of an image of such potency, and that is one of not allowing such a combination to degenerate into a pornographic exercise, something that could all too easily be allowed to happen without enough care. The photograph, which was taken on a Mamiya RB67 and Kodak Tri-X rated at 200 ASA, was – unlike some of Carlos Clarke's images – shot in a relatively uncomplicated manner, the bulk of the picture consisting of a single negative. Only the swallow was photographed separately on the 35mm format and put in later.

A successful erotic image is something that is very difficult to quantify, says Carlos Clarke, and hence one's own instinct must be allowed to play its part. But one thing is certain, which is that in the gradual gaining of confidence in picture making, one progressively relies less and less on the otherwise more conventional forms to justify one's own purpose. Certain objects and symbols that are for instance popularly regarded as good source material and loaded with sexual connotations and symbolic potential, can be confidently discarded and ignored for the future. The human sensibility seems happy to pick up on those as yet unknown and more sensual triggers of a natural urge and sexual response.

The image in Carlos Clarke's photograph causes us to answer rather warmly to its embrace. This is a place where in a way we would quite like to be, on this rather summery balcony with its freeness of air. Lingering, somewhere, however, there is a threat of something; this ruling lady with her black bird of paradise eyes seems to have some conversation with that foreboding swallow. They appear to get on too well for comfort. The faintest tint of chemical toner and a suggestion of the briefest watercolour airbrush have been used to complete the masterpiece. Carlos Clarke takes the view that an erotic image has to be credible in order to succeed, it has to be believable. Indeed as soon as it becomes incredible as an image, it fails to work as an erotic photograph – somewhere the line of communication is broken. For the picture to work we must be able to relate to it in this sense.

It has to be said that in his continual search for a new way to present the form of woman, Carlos Clarke finds himself referring to the work of certain painters, and he mentions Aubrey Beardsley and Allen Jones, as well as the Pre-Raphaelite group and the painters of the Renaissance. He also makes endless reference to

those at times markedly less conventional bodily shapes and forms as they exist in real life. So features of exceptional note can occasionally be of interest to him in an individual physique. Often of course these are qualities that are by no means generally held to be beautiful, judged by the standards of present-day taste. Nevertheless they may be physical features that have a personal appeal for him, and he may seek to resurrect an awareness of them from an era with different standards. It is understandable that he often uses ordinary people for his models, and those who have caught his eye, rather than professional models hired for a shot. Certainly the result here is clearly that of a highly charged and fantastic piece of photographic workmanship, as well as that of a richly influenced and wild imagination.

Whatever relationship exists between women and women, we can see at once that not all is rock steady in Graham Hughes' little confrontation. The glass of Champagne – understandably – comes hurtling across the whole room. She has been carrying on with this cad for a while, of course, and so it's fair enough that she should get a quick cold splash before she has the audacity to sample another portion of his lobster. This 'reportage fashion' shot by Hughes was actually taken for a Vogue promotion for Brown's fashion emporium. Note the ease with which the black strap slips over the shoulder, while the priceless dress hangs unperturbed in its magnificence.

Hughes was himself caught out by the picture. He had in his wily way conspired with the Brazilian waiter/boyfriend (the model Tuty) to get the Champagne thrust at an unexpected and duly surprising moment, which would cause the model – Renata – to respond in her own way. Having issued these surreptitious instructions to the man with the glass, who with his scarce command of English and heightened sense listened only for the word 'now' as a signal for action, Hughes walked back to his camera. He unwittingly uttered the word, long before any action was due to begin. His motor-driven camera and its flash units nevertheless managed to capture this fiery Niagara at its peak, and just before tempers subdued. Never has a 'scene' been documented so graphically, a truly moving still.

Hughes's Nikon and its 24mm lens has seen the argument from its own perspective and caught the broad sweep of the action as an epic. The Savoy of course survived the incident, and the girl in her inimitable way kept her cool with a replaced face that was specially stripped in later.

At a hen party on the River Thames, Homer Sykes's male stripper prances with sufficient abandon before his variously appreciative group of onlookers, the cool and calculating as well as the wondersome. In the same way that the stripper has to warm up for his particular act, Sykes the photographer makes it clear that in such a predicament he has to as well. Taking pictures with a bounced flash off a low ceiling, he has already made his own distinctive impression on this all-female assembled company. It helps in such an intimate situation, says Sykes, if you can establish a positive presence of yourself in such a close environment. Not to be seen secretly snapping away pictures from some dark corner can prove to be important, and if people can clearly see what you are doing and attempting to achieve, then this is less likely to make them suspicious of your movements, and more likely to put them at their ease. In this way you can happily become a part of the party, in spite of being outnumbered. As well as this, a photographer may see that in such places, and wherever human attention is focused more centrally, there human expression will reveal itself in all its variety.

Sykes has proved yet again that revelations can occur at the drop of a hat, or at least when a bank of cameramen await the appearance of an altogether starlet, at the entrance of a theatre in Cannes. Putting together people must surely at times be as difficult as putting together a picture, and yet without hesitation and quite instinctively this lady flashed, and Sykes flashed her directly in return. For while some have their egos rebuilt, others have their reputations also to consider.

Sykes, who used this picture for his publicity card, found to his surprise, as an editorial photographer, that a number of advertising agencies promptly began to telephone him to ask to see his 'book' – his working portfolio. It seemed astonishing to him at the time that

BOB CARLOS CLARKE

anyone could imagine that such an entirely spontaneous event could have been a set-up job. The sheer intricacy of detail of any such venture being undertaken in a contrived fashion would of course have set any photographer and agency art director a mammoth task. As it happens, Homer Sykes got the shot in one, and with little complication above and beyond his obvious ability to notice those things going on around him. An acute eye and a presence of mind did the trick in this case.

In my own picture of 'Angel Jack' in a New York bar, there is no hesitancy on the part of this glittering queen, who pouts at us all and tempts us as best she can to join the club. I photographed this temptress in the available and quite bright light of the bar, where on proper introduction 'she' made a willing and helpful subject. A flash picture of Angel Jack would probably have been ruinous, since it was important for me to pick out the details of her distinctive and reflective person, and her sequined charms. Had I attempted to obtain photographs of this kind through ambient light and without some polite and friendly conversation first, then I think that I could have been asking for problems. As it happens, I even checked with the management of the bar in order to ensure that nobody was going to get upset.

Everything went with extreme ease, since I was clearly seen to be carrying off a legitimate exercise, a picture for the sake of a picture, in other words. I do recall, however, that with all my attention to administrative detail, and my attempts to ensure that I was working on safe ground, I nevertheless still got the littlest of taps on the shoulder from some big-fingered heavy fellow, who felt he had at least to put the presence of some muscle in on this act. With some kind of reassuring mumbling noises he presently left me to the pictures. But this only confirms that try as you may, you should still consider yourself lucky in certain places to get a picture at all.

In this instance I used a fast colour film of 400 ASA, a speed of film that I would generally avoid out of personal preference in a colour picture, since I mostly dislike harsh grain in a colour shot. Then to pile Pelion on Ossa, I of course uprated the film to 800 ASA in order to get

sufficient shutter speed, to avoid nervous camera shake, and to catch Angel Jack in a split second of passion. A subject of high contrast often works well with speeded up film, whereas a more evenly illuminated subject of low contrast generally loses the necessary definition.

Martyn Goddard was fighting with the elements when he photographed Deborah Harry in New York, on a hotel rooftop and while a storm threatened to erupt. Goddard used a veritable cocktail of filters on his Nikon with its 24mm lens. A blue 82C filter was used overall, rendering the image with a distinct evening light, and a grey neutral density graduated filter was used to bring out the sky. Three flash units were used for the picture. One of these was placed slightly to the right of the camera, the other was fixed to the camera body itself, and the third unit forms the star attraction in the picture. The co-ordination of the flash units occurred through their own built-in electronic wizardry, known popularly in the trade as 'slaves'. These light-sensitive devices, which are built into the flash units themselves, respond to sudden light emitted from other flash units, so they all fire together.

In cases such as this, Goddard plans his picture carefully in advance, so that he is completely set up and prepared before the star appears on the scene. With little time available for a shoot, he frequently has to take the picture on a spontaneous whim in any case, but with the added advantage of an arranged scene and theme, he attempts to contrive the most ideal circumstances for his specific choice of picture. In this way he tries to bring together all the elements to his personal taste, to form a complete mood in the picture.

The character of the shot is that of a Screen Gems Super Hero. Deborah Harry's Schumi hairstyle whisks us promptly into a space age, and the blue laser-like light refraction caused through Goddard's use of an older model of Nikon lens shoots with great effect across the picture frame. Goddard says that regrettably he had the lens stolen some while later, and so it would no longer be possible to re-create this enhancing quality of the blue blobs for the purposes of another photograph. In other circumstances, of course,

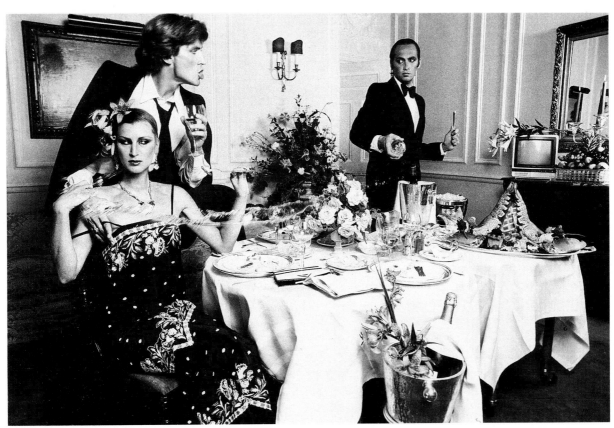

GRAHAM HUGHES

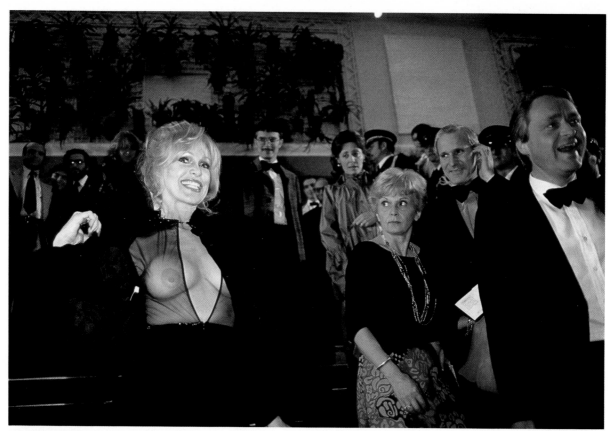

HOMER SYKES

ROBERT HAAS

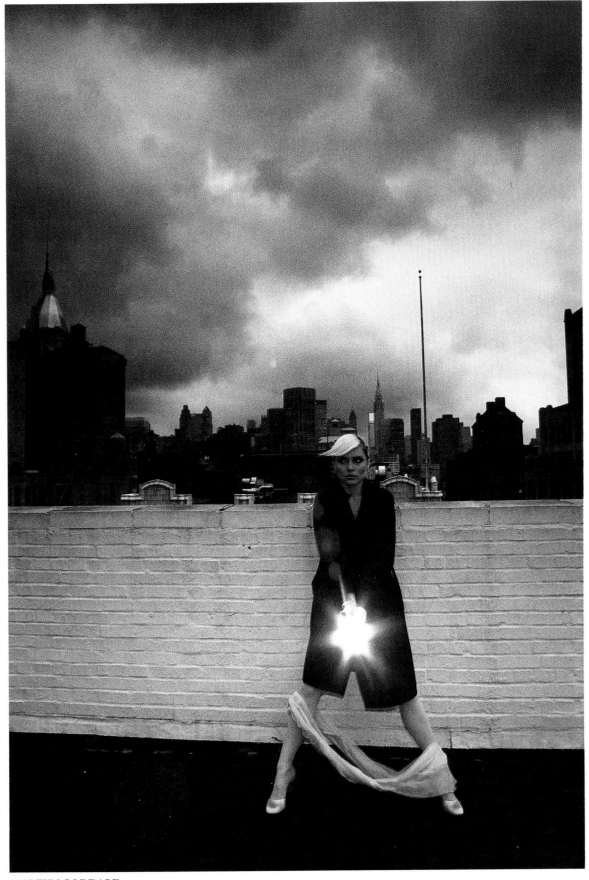

MARTYN GODDARD

such an effect in a picture would be regarded as a serious fault, but here it beams us into another era, with a Zap and a Pow.

Brian Griffin has a weighty hero in his powerful and strongly idealized, though totally anonymous, figure of a plump peasant woman in a cornfield. She is poised with her sickle as if to rend a dark and angry sky, while her red headscarf – carefully chosen – seems to stand out from this gun-blue horizon in turmoil, like a rich hot flame. The theme of the photograph, originally intended for a record album sleeve, was to run concurrent with the concept of 'breaking out', and the image is again the result of a consummation of creative elements in Griffin's head. The corn itself is a heavily loaded biblical device, and yet he had decided that the picture should somehow have a distinctly political edge to it, and so possess 'bite' and some drama. This was after all an image that in terms of its subject matter could have been quite twee, pretty, if not positively romantic.

The concept emerged of a peasant woman in her forties working in a field with a sickle or a scythe. Now a scythe, Griffin admits, would have been more accurate from a documentary point of view, being more appropriate for cutting down corn, while a sickle is intended for less major tasks. But something got Griffin thinking – the scythe has certain hellish connotations. As he says, 'That's precisely why we didn't use it on the album cover, there's something about the *reaper*'. One of Albrecht Dürer's more satanic and deathly woodcuts springs to mind. Fortunately the sickle is in any case a much more political implement, and hence it was used instead, an instantly recognizable silhouette.

A peasant woman of a distinctive kind was of course required for the photograph and it was here that Griffin consulted the stylist Jacqui Frye, for a matter of pinpoint accuracy. 'Oh, you need an Eisenstein "October" peasant', she promptly responded. Griffin supposed this to be the vital formula, and let her get on with the job. The crucial red headscarf was Jacqui Frye's own idea, and it shows how someone other than the photographer can contribute greatly to the making of an effective image.

To add to this formulation, Griffin says that he needed a piece of landscape that could resemble the Russian Steppes and be an area with a flat horizon. A suitable location was found close to a disused airfield near Harlow, and that is where the picture was finally taken. Griffin stresses that it is his increased knowledge of artificial lighting methods, as learned while working within the constraints of the studio, that has made it possible for him to produce such an image. A measure of his own light was added to this open landscape of his, but it is a critical and well-measured dose.

Griffin, who is naturally influenced by certain masterpieces of painting, has observed that one of the most important aspects of lighting – whether one is dealing with painting or photography – is the level of light that one puts back into the subject. Most photographers put too much light back into the photograph, he says. From this point of view it is important to realize that in a case such as this, there is already light coming from another source, the sky and the landscape itself. Hence with light emanating from the subject, one has to be very careful how much artificial light is added to the subject. Again, Griffin says, 'Having looked at many paintings, I have often noticed the effect brought about through an amount of light that has been "filled-in" from the front by certain painters. It can be a very delicate and critical balance. My very basic principle of using artificial lighting outside – wherever circumstances permit – is to watch where the sun is coming from, and then to light accordingly and in relation to the sun.'

This photographic masterpiece of Brian Griffin's was, he says, a relatively easy one to make, and all the pictures that he took on that day were taken within a period of about two and a half hours of pure photography. Even so, he reckons that he was there for most of the day waiting for the appropriate light, as well as waiting for the periodic showers to stop.

When the bespangled star Elton John was performing at Los Angeles Dodgers Stadium, Terry O'Neill was there ready on stage with him, though a little in the background so as not to be in the way. At the right moment, and O'Neill knew exactly when in the number that would be, he

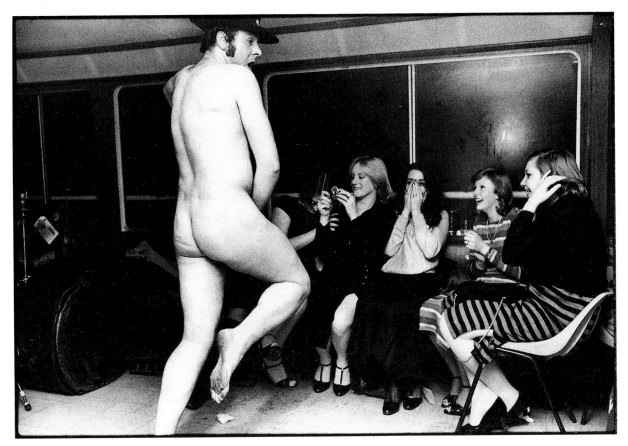

HOMER SYKES

would pounce out like a cat from behind a bush and catch this leaping Elton John in thin air and mid flight and before the multitude of 200,000 admirers. O'Neill had worked with Elton John before, and so he knew his prey well. Because of this he confesses to some logical anticipation of the star's moves and sudden instincts.

It is surprising that O'Neill took the airborne John at a quite slow shutter speed of 250th of a second. Having been a Jazz musician for a time, he knows something about timing, and it is this that is of the essence in getting such a picture, he says. In being prepared for that very precise beat of the moment, he captures its climax with little effort and then retires to the camouflage of the stage, to sit again in wait. Although it is obviously necessary to have the confidence of the artist with whom you are working, it is also clear that in Terry O'Neill's case, his own confidence has also got him a long way. O'Neill says, 'Naturally you wouldn't have this kind of access to the stage in the first place if the artist didn't trust you. I knew when it was possible to move in

to take a photograph and also when I should stay away. You must be careful never to abuse the access that you have to a star in such a situation, and you can't under any circumstances interfere with the act, of course.'

In this particular instance and with O'Neill's own wilful intent to grab the audience as well as the star, he confesses that he was well out of the way before Elton John hit the ground. Elton John was caught at this peak performance of his with a 35mm lens on a Nikon. The depth of field in the picture, considering the nature of the subject, is fairly astonishing. But then this is no lucky shot. At a less athletic moment at the same blockbuster concert O'Neill captured Elton John contemplatively, and evidently considering his keys deeply. The evening light was by this time coming on, says O'Neill, and a total freak of light at a split second threw this keyboard up into the star's fish-eye gaze. Elton John's identity is maintained, one should note, since these are not mirror reflective sunglasses, but rather, large and lightly tinted lenses, that for all their dimensions

TERRY O'NEILL

TERRY O'NEILL

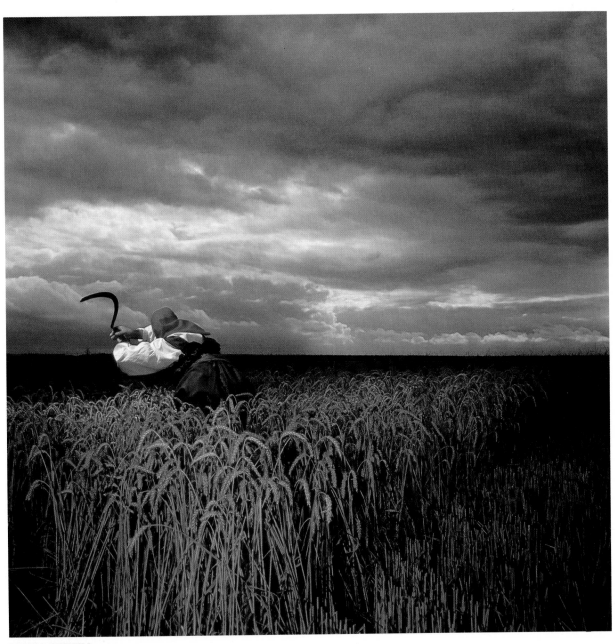

BRIAN GRIFFIN

do not obscure his person. He evidently has not become too lost in his success. O'Neill beamed in on the spectacle with a 180mm lens, to make a tune of a picture

All human identity has been lost for ever in Chris Smith's unique vista into the bowels of Hell. The vision of the poet Dante's *Inferno* has truly come to life. All are absorbed in this absolute spectator sport, and these brave young men rule unquestionably with their fire and smoke batons. Black banners wave in the final victory, and lesser mortals descend – their hands and arms covering their faces – like damned and lost souls in Michelangelo's Last Judgement. Chris Smith is of course a photographer of sport, and it was while he was covering the football match between Liverpool and Roma on Rome's home ground that he came face to face with the end of the world as we see it here, a momentous distraction from the game itself.

Smith was not the only photographer to be on the scene, and yet for some reason, and to his knowledge, no one else produced an image of such climactic power of the event. Smith attributes this to the fact that the atmosphere at the time was really rather unpleasant, with objects great and small being flung around, in air that was scarcely breathable. Smoke bombs and fire crackers abounded, releasing their noxious fumes. Most of them being home-made, they also released white particles that settled on the massed spectators, making them look like last survivors huddled in the extreme cold of a nuclear winter.

The Italian fans in this picture can clearly be seen to represent a cult whose ultimate endeavour is to terrify the opposition at all costs. Smith has observed that at times these 'supporters' can even be seen to sport the Union Jack, as a symbol which they have adopted for a kind of universal hooliganism. Smith has spotted this phenomenon with Greek fans as well, for instance. From what he says, it appeared at the time that some photographers were hoping to photograph the commotion at a safe distance. However, Smith makes it clear that it would have been impossible to achieve an image of this kind with a telephoto lens, since the 'compressing' effect on space brought about through the use of

CHRIS SMITH

ADRIAN FLOWERS

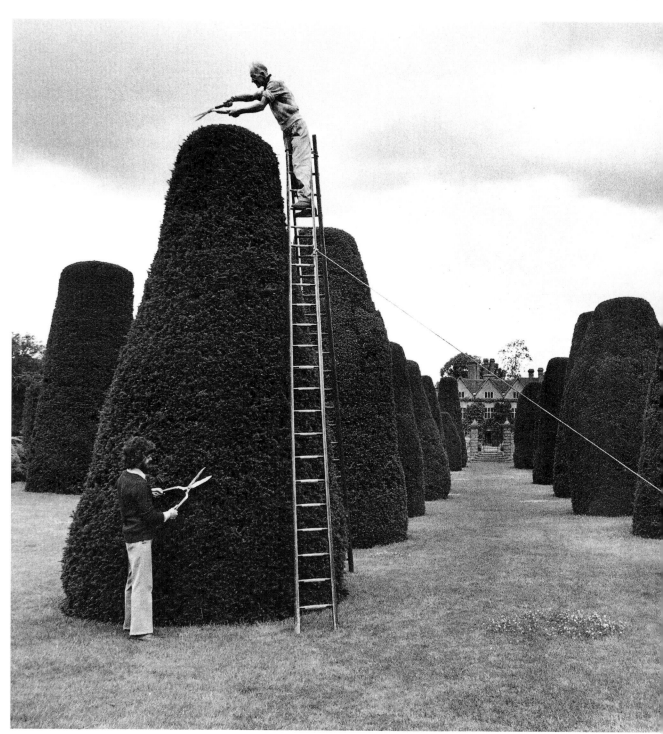

DAVID MANSELL

such a lens would automatically have compacted too much smoke in the atmosphere between the camera and its subject. Smith took the picture with a Nikon and a 35mm lens, which is as good as saying that he was in the thick of it when he took the shot. It was getting close to dusk, hence the outstanding brightness of the flare in the foreground, and the photograph's exposure was 1/60th of a second at f/5.6.

Smith admits that although the smoke was swirling this way and that, and causing the scene to change from moment to moment, he knew that he had a great picture in the camera. The picture desk at *The Sunday Times* agreed with him and were brave enough to put the picture in their sports pages, where others might have said, 'What has this to do with sport?' But then, as we all know, football is a religion as well as a pastime.

In order to experience some harmonious and well-ordered peace, one can go to David Mansell of *The Observer*. In his 'Congregation' of stately yew trees – for this is what they represent – every little floret is kept in check with a regular snip. From the time-honoured grounds of Packwood House, at Lapworth in Warwickshire, the photographer has drawn a perfectly balanced picture of ultimate craftsmanship, with mathematical discipline and precision, and the artful counterweight of a trapeze artist. Mansell knew these trees, it should be said, and he knew that they were about to receive their annual trim. With this in mind he went along to witness their topiary. What began as a topic of feature interest suddenly became a matter of up-to-the-minute news interest, for this was to be the very last time that the assembled company would be shorn from this distinctive spidery ladder. Because of 'cuts' elsewhere, automation was to take over for future years.

A line of delicately pirouetting and highly independent assessors, as depicted by Adrian Flowers with his own particular finesse, leaves us in no doubt that they will draw their own conclusion about the matter in hand. Glasses are what they hold in judgement, not wine. Each in their own way, they appear impressed, and they have to, since this was an advertisement for Royal Doulton full lead crystal. For an inherently subdued subject, this photograph is full of

animation. The quiet and even illumination of the group of four naturally establishes them corporately, and yet their individual and well-chosen stance symbolizes a wholly personal opinion on the part of each connoisseur. Not one of these stately figures is going to be browbeaten for a second into believing what he does not know for himself. Clearly, none of them is going to be led by anything other than his own instincts. In matters of taste, that is of course the vital criterion.

Flowers illuminated his subject with great gentleness from the foreground, so that we are barely aware of any artificial light at all. The temptation, with such a sizeable expanse of window in the background of the chandeliered hall, would be to let the viewer of the photograph assume that light naturally abounds in such a place. In large stately homes there is often a lack of light, and so Flowers has allowed his carefully controlled light to imitate the soft shadow of a rather cool space and has let nothing take over the scene of contemplation. Since there is no stark lighting in the photograph, we may dwell a bit with these experts and their scholarly gaze, lost in their little worlds of shimmering and chinking cut crystal.

Someone with a singular dedication to the task in hand is Arthur Steel's Wimbledon Umpire. He must keep his eye on the ball and won't let anyone play tricks on him, of course. Steel photographed the attentive man on a 200mm lens on his Nikon back in 1966. The photograph is a characteristically devious one, in that it was made as a double exposure on to a single piece of negative, and with a degree of co-operation on the part of the official. Each of the two exposures was taken at less than the normal value, in order that the superimposed and accumulative density of the negative should be approximately the same as a normal single exposure. Steel had to ensure that the alignment of the picture was perfect, in his one shot on top of the other, so that the image functioned absolutely in its effectiveness, and so that you could not spot the join.

A double exposure, says Steel, is quite a difficult thing to make using the 35mm format. Having to rewind the film to pinpoint accuracy can be a very hit or miss affair, and a great deal of

ARTHUR STEEL

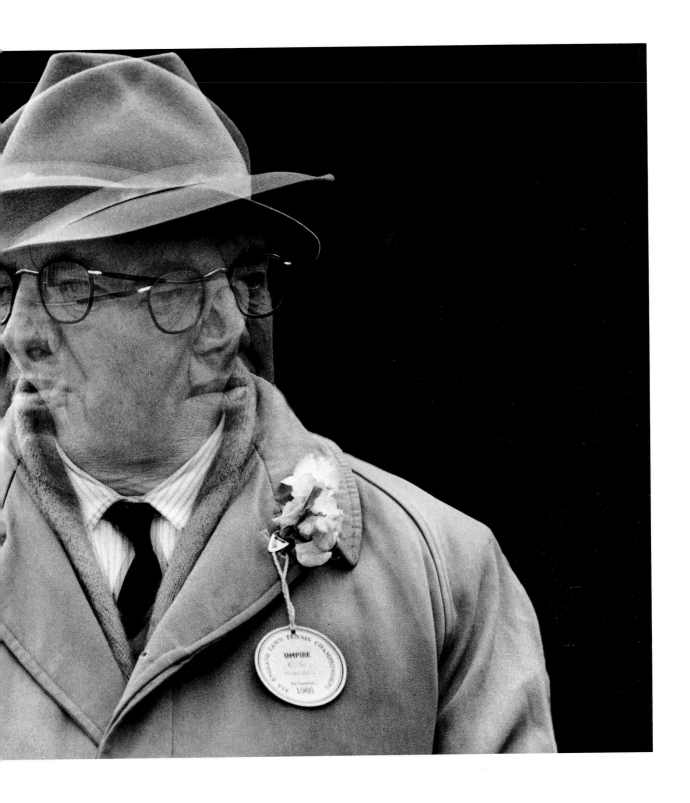

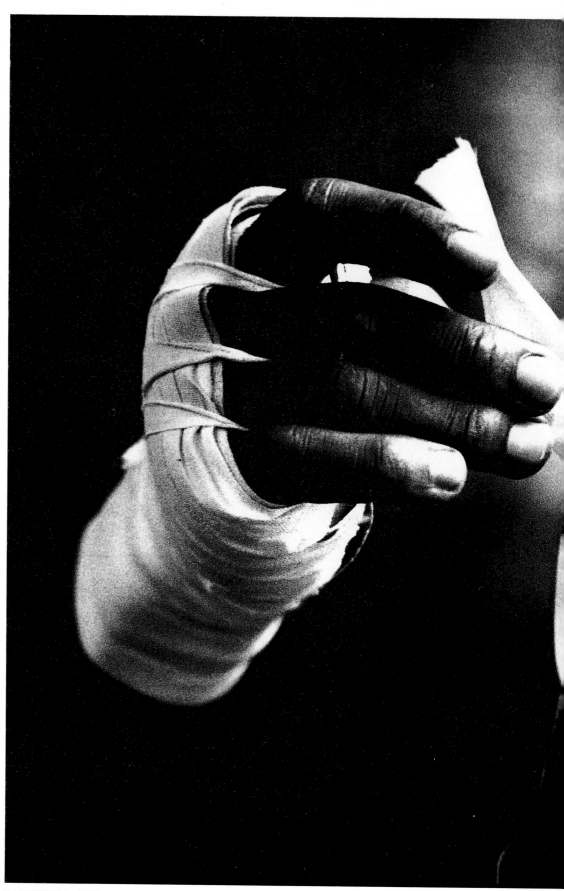

EAMONN McCABE

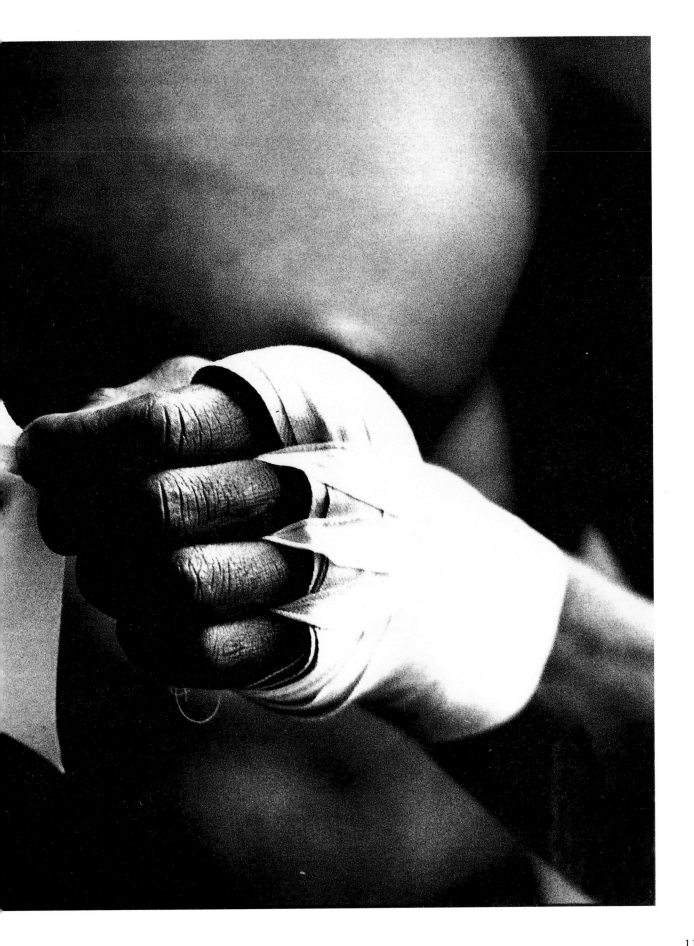

trial and error can be involved in the production of such an image. Steel, who admits to being a trickster from time to time, nevertheless recognizes the importance of the fact that a trick must not merely work, it must be seen to work really well. For him this often involves quite a lot of advance thinking as to how a method and technique may be tastefully and artfully brought to bear on what must be a highly suitable subject – in the first instance. For him there has to be a blending between the subject and one's technique as related to the subject – in other words, a sympathetic co-operation between the two. One is, after all, in journalistic terms obliged to tell a story in a picture, and from that point of view his umpire is captured quite nicely in the course of play.

Features of interest can catch our attention at a mere glance. A most definitive part of Steve McQueen has been framed up by Terry O'Neill as part of a 'jigsaw' of the legendary figure. When O'Neill, on one of his first jobs for an American magazine, was forced to produce an effective visual essay in impossible circumstances and with virtually no time available, he instinctively reacted by photographing McQueen in distinctly recognizable sections. In the tour that he made around the man in that dark office, and while McQueen sat behind a desk completely unprepared, O'Neill managed to encapsulate a most feelingful part of the immensely popular actor.

O'Neill says that in ideal circumstances this is the type of photographic assignment that one would rather undertake in a studio environment. As it was, he was shooting on an 85mm lens with a wide open aperture that made life very difficult for him at the time. Depth of field at such close quarters became a critical matter and so his focusing had to be extremely accurate. His f stop did not help on this score. This is what you call fighting with the camera. O'Neill confesses that a major impetus in the making of the photographs was the sheer presence of the actor before his lens. This was the kick in the pants and the prime motivator for O'Neill, the thing that got his adrenalin running.

Not everyone has such definitive features, says O'Neill. From his experience there are only a very few filmstars who could be approached photographically in this distinctive and characteristic manner. It seems that the rest of us are more homogenous. Certain people have eyes or other parts of them that you could place immediately, according to O'Neill, and he says that in McQueen's case there were a lot of things going for him in terms of the built-in trade symbol. Other idols such as Paul Newman, Cary Grant and John Wayne would probably have made as unique a slice of life.

Eamonn McCabe has drawn in closely to his subject. The hands of the boxer Sylvester Mittee appear as prayerfully as the binding of a nun. The black skin contrasts with the white linen tape, and with such meticulousness that these fingers, so delicately poised, could hardly have anything to do with boxing. The piece of tape held between the hands only emphasizes the careful touch that goes into the preparation of the boxer for the purposes of the punch. What makes McCabe's picture outstanding is its inherent contradiction. There is a symmetrical beauty, of course, to the wound round white linen, and one that would not have functioned against a white skin.

McCabe, who is also a photographer for *The Observer*, periodically photographs boxers, and he has found himself intrigued by the paraphernalia of the back room effort. In a small gym over a pub in King's Cross he shot this picture of Mittee, close to a window, and hence was able to use the already atmospheric qualities of available light from that ready source. His completely investigative 180mm lens seeks out every little twist and manipulation, with a genuine sense of anticipation of a part that's to be played for real.

As a detailed departure from a day's more normal work, McCabe regards a picture of this kind as a fair bonus. These hands, however, are not of high renown, and so the picture is, from a newspaper's point of view, a difficult one to publish, where by comparison those of 'The Greatest' proportions would have found more than a few columns' space as a 'portrait' of exception. The picture of these dual personality hands was taken with McCabe's own sense of dedication, and his awareness of the boxer's craft and feeling of purpose.

TERRY O'NEILL

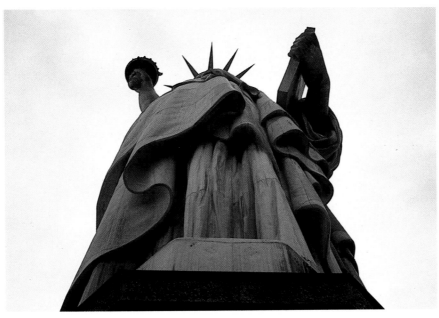

ROBERT HAAS

For whatever purpose Miss Tara Joyce exposes her tongue to the wind, it is clearly seen not to be in keeping with her otherwise angelic embodiment of pious perfection. Arthur Steel had been asked to photograph her as a favour when she promptly diverted her dedicated attention to more earthly concerns, and to ground level. Steel admits that he would never have conceived that this good turn, which involved photographing a young girl's first Holy Communion, should have turned out to be a world-beating picture for him. Now naturally he had already taken a more formalized presentation of the ceremony, when a hint of Lucifer began to make a twinkle amidst the finery. This, Steel knew, was the opportunity for a *real* picture. The photograph sold first on the off-beat back page of *The Mail On Sunday*'s 'You' magazine, and thereafter was published endlessly around the world.

A picture of this kind speaks utterly for itself, and hence requires no caption. Steel's favour turned to gold when he was promptly awarded Kodak's picture of the year, which consisted of a hefty fee for his printing skills as well as a sizeable sum for the photography itself. Arthur Steel is of course also very much on the look-out for contrasts in a picture, abundant contradictions dare we call them, and so Tara Joyce's screwed-up face does not go entirely amiss at this important moment of her inauguration.

A slightly eccentric angle of view transforms my own Statue of Liberty into something beyond the norm. Yet she remains the distinctive figure in her well-weathered classical robes. The conventional angle of view can always be put aside for a while, I feel, in order that we may be free to see things from another angle and a characteristic viewpoint. While it is possible to explore endlessly and beyond the horizon for a good photograph, it should be a basic tenet of the creative photographer to work with essentially available material.

In New York it is fascinating – though by no means surprising – to discover that few residents of the City have been to the top of the Empire State Building. But then how many Londoners have been to St Paul's Cathedral's 'Whispering Gallery'? The whole world, we could say, is essentially recognizable; we are familiar with the best part of our surroundings and take them for granted. This, however, is a fundamental mistake on anyone's part – let alone that of the photographer, who must always allow himself to be surprised and at times amazed by the everyday and the basic. To be free in your imagination is the real liberation of the photographer, since we are after all not obliged to draw a conventional diagram of our view of the world, but rather to see things as we choose to see them. Ultimately, nothing may be too simple for an image, and what you exclude from the picture often proves to be as important as what you include. To place faith in your own judgement of things, and to see matters with an independent eye, is the true art of the cameraman.

Brian Griffin's photograph of the end of Jensen Motors causes us to draw our own conclusions. The rigidly fixed hands are affirmative in the extreme, while last moment papered solutions stare starkly and with little hope. This geometrical exercise of Griffin's is an absolute negation. These businessmen at the bare boardroom table have had their chips, but then the end comes quickly.

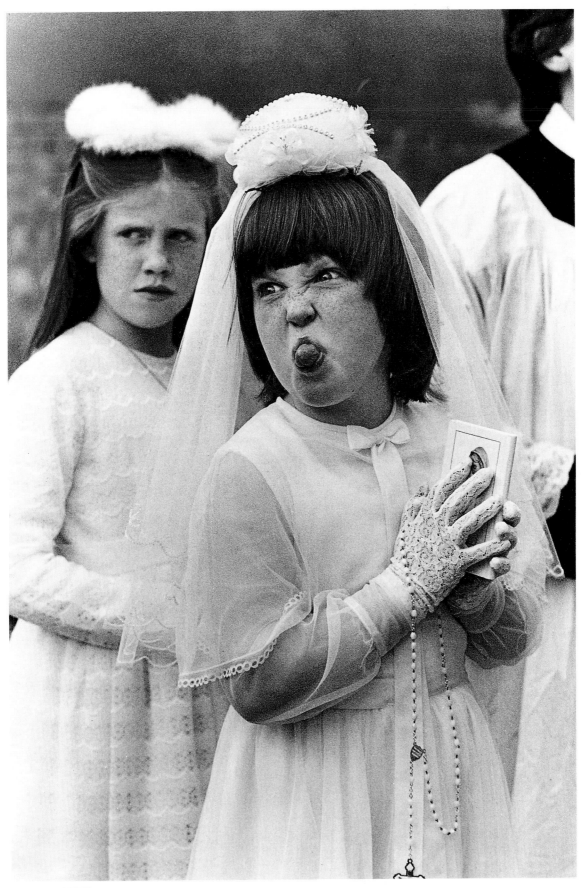

ARTHUR STEEL

BRIAN GRIFFIN

INDEX

126